Lake Tahoe
Through Time

CAROL A. JENSEN
NORTH LAKE TAHOE HISTORICAL SOCIETY

You, Irreplaceable You
(From the lyrics to "Embraceable You" by George Gershwin, 1928)

America Through Time is an imprint of Fonthill Media LLC

Fonthill Media LLC
www.fonthillmedia.com
office@fonthillmedia.com

First published 2015

Copyright © Carol A. Jensen 2015

ISBN 978-1-63500-031-3

All rights reserved. No part of this publication may be reproduced, stored in a retrieval system or transmitted in any form or by any means, electronic, mechanical, photocopying, recording or otherwise, without prior permission in writing from Fonthill Media LLC

Typeset in Mrs Eaves XL Serif Narrow
Printed and bound in England

Connect with us:
www.twitter.com/usathroughtime
www.facebook.com/AmericaThroughTime

America Through Time® is a registered trademark of Fonthill Media LLC

Introduction

Lake Tahoe's history reflects in microcosm the nation's 270-year dilemma on the best use of the natural environment. This book reflects that quandary as it depicts the changes in the Lake Tahoe area during our generational memory as portrayed through pairings of images from glass plate negatives, black and white safety film, 35mm Kodachrome, and digital images. John C. Fremont and Kit Carson sighted the Lake in 1844, noted its longitude and latitude, and moved on to map better overland routes to Mexican Alta California. From their perspective, the Tahoe Basin was merely a wilderness obstruction to avoid while traveling the main emigrant roads west to California. The Lake Tahoe region was best left to the indigenous Washoe people. So it stayed essentially until the 1859 Comstock Lode discovery of silver and gold ore at Virginia City, Nevada. At the same time, the first professional photographers arrived and documented our first views of Lake Tahoe: way stations and cattle ranches. These images taken by photographers Carleton Watkins, Eadweard Muybridge, Thomas Houseworth, and others are still hugely popular.

We begin our time travel around Lake Tahoe with images of the mid-to-late nineteenth century. As photographic technology changes, so do the purposes and uses of the Tahoe region. Silver nitrate emulsion on 8" x 10" glass plates captures the remains of forests that were clear-cut to fuel and reinforce Nevada's mines. Photographers captured images of locomotives, tree booms, lumber mills, flumes, and boarding houses in the Tahoe Basin as easily as images of industrialized New England. What do these places look like now? How have they changed during the twentieth and now twenty-first centuries?

Our generational memories of Lake Tahoe begin with the decline of the Virginia City area mines in 1886 and with it the demise of the Tahoe timber industry. Tahoe lumber baron Duane L. Bliss did not invent the hospitality industry at Lake Tahoe, but his vision and personal fortune transformed it. From 1887 to 1908, Bliss converted his lumber camp at Glenbrook, Nevada, into a resort, launched the 169-foot steamer *SS Tahoe*, constructed the Tahoe Tavern in Tahoe City, California, and instituted regular railroad service from Truckee to the Tahoe Tavern pier. In this manner, a percentage of every tourist dollar at Lake Tahoe found its way into the Bliss-controlled Lake Tahoe Transportation and Railway Company.

The complete transformation of Lake Tahoe from essentially a private timber forest to a tourist-focused hospitality center parallels the introduction of nitrate film negatives and the use of photography as an advertising tool. The Tahoe Tavern and the splendor of Lake Tahoe were captured by Harold A. Parker and incorporated in the earliest Tahoe Tavern brochure dated 1907. Florid prose describing the beauty and accessibility of the Lake by railroad and steamer complemented Parker's images to attract wealthy San Francisco clientele to the Tavern. His panoramic, portfolio, and postcard images are still appreciated, published, and collected today.

During these early twentieth century years, the Bliss family sold large tracts of "spent" (i.e., worthless) Tahoe Basin land to the "who's who" of California. Thousands of acres were sold and became private compounds for banker Isaias Hellman, financier Edwin B. Crocker and family, industrialist Henry J. Kaiser, shipping magnate Stanley Dollar, philanthropist Lora Knight, and many others. Ecologically, we can thank eccentric George Whittell, Jr., for single-handedly purchasing and refusing to develop most of the Nevada side of Lake Tahoe. The introduction of cellulose acetate film or "safety" photographic film in 1923 made photography affordable and accessible to the amateur. This book has photographs of private compounds and their evolution into parks, developments, and favorite haunts thanks primarily to amateur photographers of the last ninety years. This picture album traces changes to families, favorite hostelries, beaches, casinos, campsites, ski runs, and 100 years of Emerald Bay and Fannette Island.

In the twenty-first century, the land in the Tahoe Basin is subject to conflicts between private development interests and public land advocates. The balance between ecologically sound uses and economic development is found in an awkward, politically negotiated, middle ground. This photographic juxtaposition of Lake Tahoe through time reveals the changes, the tension, and ever-changing attempts at resolution of this struggle.

This book is organized by combining the popular "wishbone" automobile route to Lake Tahoe and the clockwise mile markers dotting its shores. The graded road connecting south and north Lake Tahoe via Emerald Bay, completed in 1913, still beckons the auto enthusiast 100 years later. Oldsmobile, Reo, and Packard motorcars equipped with spare tires, spare parts, and a mechanic adventurously traveled on what is now Interstate 80 from San Francisco to Sacramento to Truckee and Tahoe City, drove south on Highway 89 along the west shore of Tahoe, and returned via Placerville along the other leg of the "wishbone," now Highway 50. Modern-day motorists traveling via this same historic route arrive at Tahoe City, note mile marker 0 (zero) at the Truckee River outlet bridge, and can follow the markers clockwise to circumnavigate the lake. Others may wish to leave their Subaru, BMW, or Chevy motorcar at home and make the journey around the lake by bicycle, Vespa, or boat to enhance their appreciation of Lake Tahoe through time.

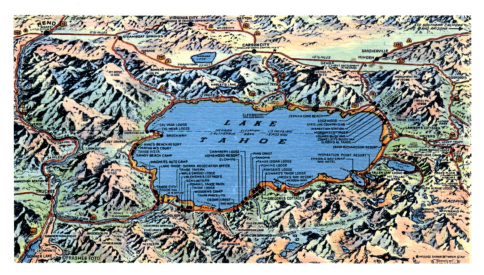

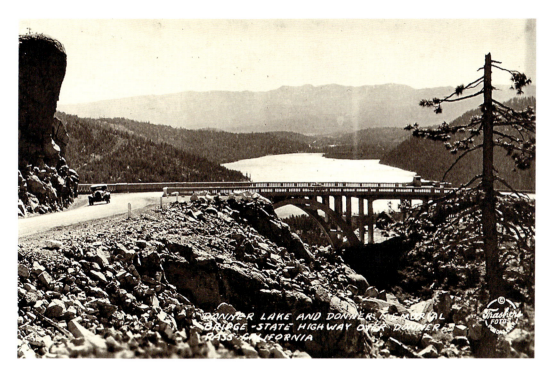

DONNER SUMMIT AND RAINBOW BRIDGE: Heading east from Donner Summit to Donner Lake, old Lincoln Highway can only hint at what Donner Party members felt as they struggled west with their relief parties in 1847. The modern Rainbow Bridge, also known as the Donner Memorial Bridge, was originally built in 1926. It was rebuilt in 1996 and continues to beckon visitors to a wonderland of mountain, snow, and summer recreational possibilities. (T: DD)

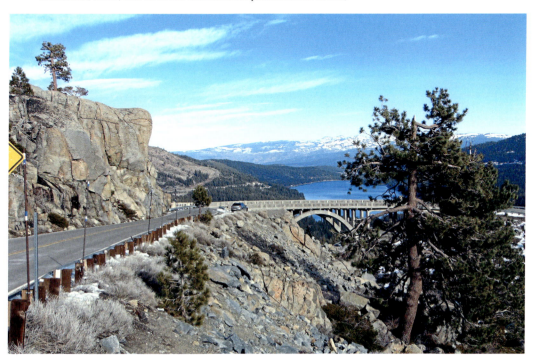

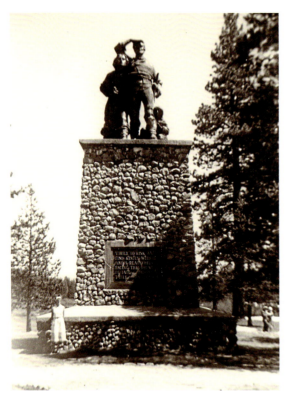

Pioneer Monument: The Pioneer Monument, also known as the Donner Monument, stands at the eastern end of Donner Lake. The figures stand on a twenty-two-and-a-half-foot-tall pedestal representing the depth of the snow on the Breen cabin site during the tragic winter of 1846-47. The monument was built with private donations and dedicated on June 6, 1918. For many, this monument and its inscription are the western pioneer equivalent to the Statue of Liberty and the famous poem on her pedestal.

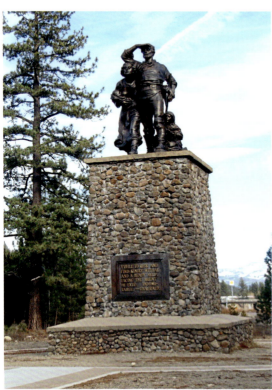

Graves Family Monument:

The major family groups comprising the ill-fated Donner party were camped throughout the Truckee area. The Graves family cabin site, originally marked with a large cross, is located just south of the agricultural inspection station located on Interstate 80. It marked the site until modern Interstate 80 replaced Highway 40. The cross and plaque are now located north of Interstate 80 at the entrance of an outlet store mini-mall.

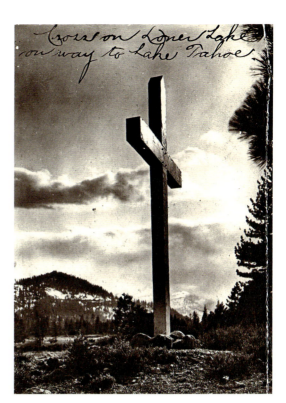

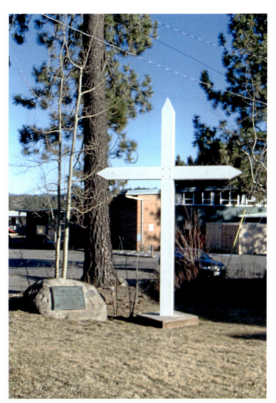

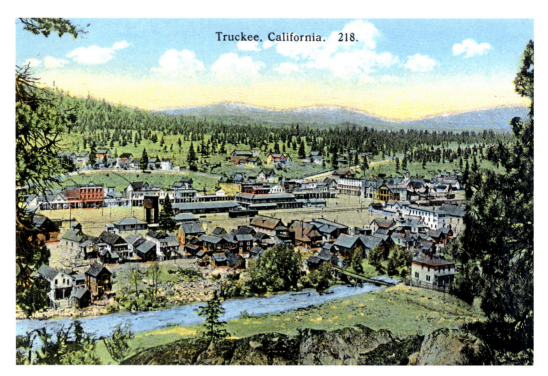

CITY OF TRUCKEE: Truckee, founded in 1863, is the typical railroad town born of transcontinental railroad construction. Survey and town lot sales of the Central Pacific Railroad's alternating sections along the right of way created an instant city and a real estate boom here. Chinese settled the opposing side of the railroad right of way, south of the Truckee River, after construction of the railroad.

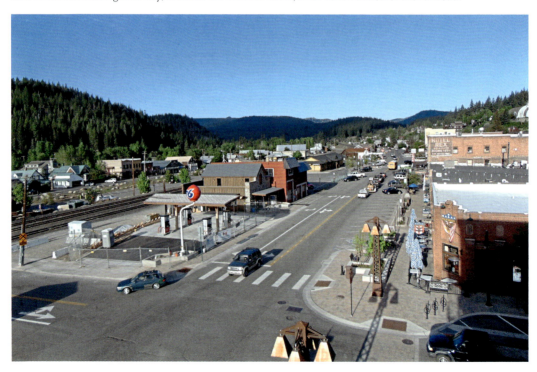

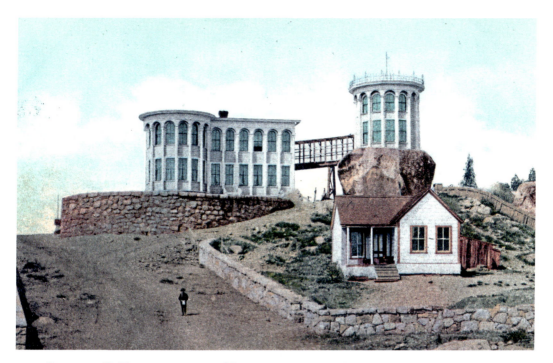

CHARLES F. MCGLASHAN AND MUSEUM: McGlashan (1847-1931) was the model "booster," a lead citizen, the publisher of the *Truckee Gazette*, and the state congressman representing Truckee. His early scientific work included the first accurate depth measurement of Lake Tahoe. His home, the most prominent in town, encompassed a natural phenomenon (rolling rock), Lepidoptera displays, and relics of the Donner Party. In 2015 he is best known for bringing recreational winter sports to the region and for his seminal *History of the Donner Party*. (T:AS)

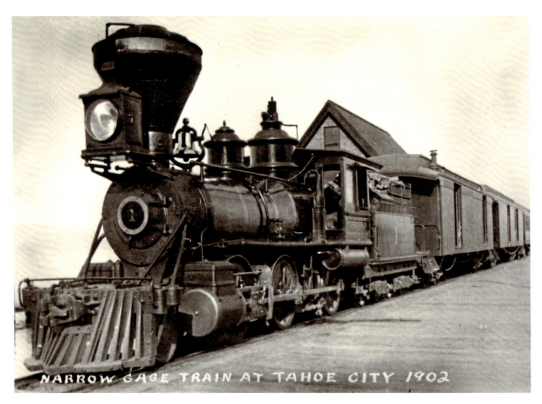

THE *GLENBROOK* LOCOMOTIVE: The nineteenth century was the age of steam and locomotive power integral to exploiting the natural resources of the West. The Baldwin Locomotive Works, Pennsylvania, built the narrow-gauge *Glenbrook* locomotive in 1875 for the Carson & Tahoe Lumber and Fluming Company. The D. L. Bliss operation used this workhorse to move timber from Glenbrook to Spooner Summit, Nevada; later, it was used to move passengers and freight between Truckee to Tahoe City. (T:NHS) (B:NRM)

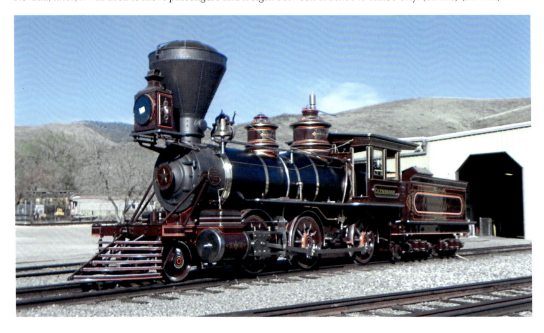

THE GLENBROOK LOCOMOTIVE CAB: *Old Number 1*, the *Glenbrook*, was a transportation mainstay of Lake Tahoe for fifty years. Upon retirement, it served as a static exhibit next to the Nevada State History Museum for innumerable children to play on. Today, thanks to the Nevada State Railroad Museum and a twenty-year restoration process, the *Glenbrook* has steamed up once more as one of only four wood-burning locomotives in the United States. (T:CRM)

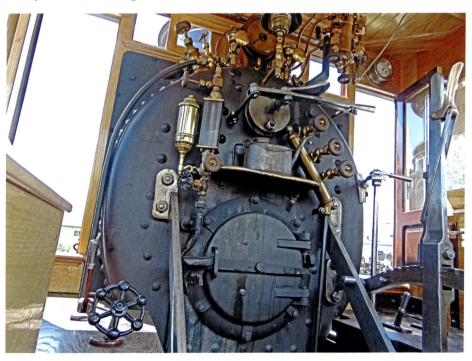

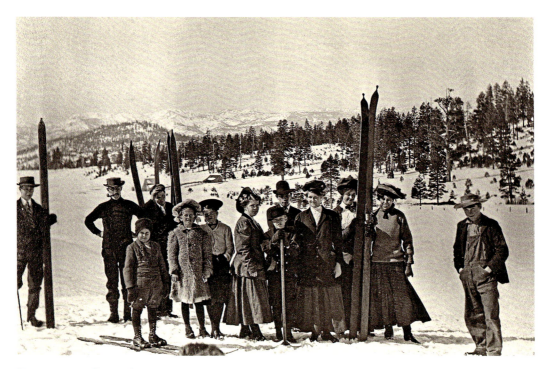

LONGBOARD SNOW SKIING: Longboard skis, made famous by John A. "Snowshoe" Thompson (1827-1876), had their recreational origins in the Sierra Nevada when miners strapped barrel stays to their shoes and plunged headlong downhill. Miners soon fashioned Douglas-fir staves into skis between 10' and 16' long. With a gentle nudge, competitors would fly straight down the course, and would turn and stop with the aid of one pole between their legs! (T:LTHS)

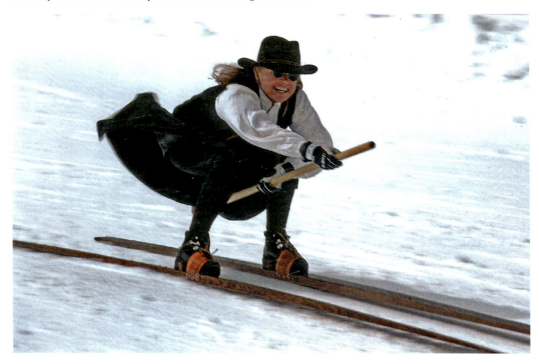

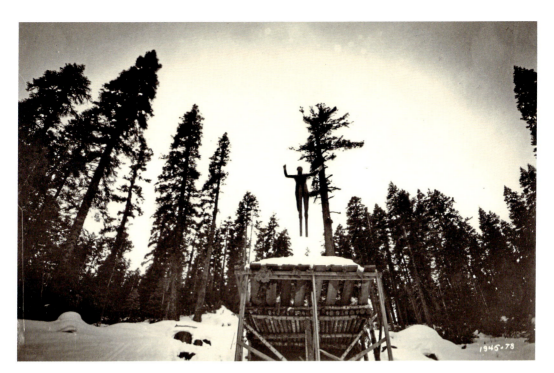

OLYMPIC AND PROFESSIONAL SKIING: The Lake Tahoe Ski Club made wonderful use of "Olympic Hill," the Tahoe Tavern Ski and Jump area. However, it was Squaw Valley, the one-time gold mining camp and summer cattle pasture, that became the site of the 1960 Winter Olympic Games. The Blyth Ice Skating Arena was constructed in 1959 as a temporary venue for ice hockey and speed skating. It closed in 1983, when a huge snow accumulation caused the roof to collapse. (T:NLTHS)

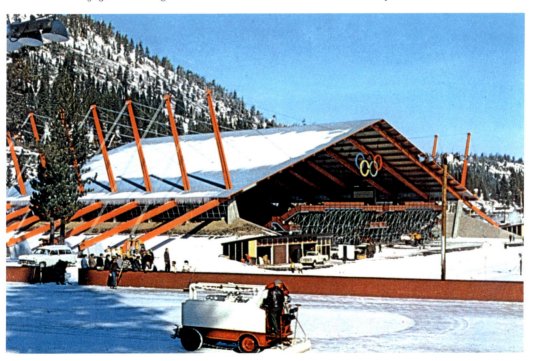

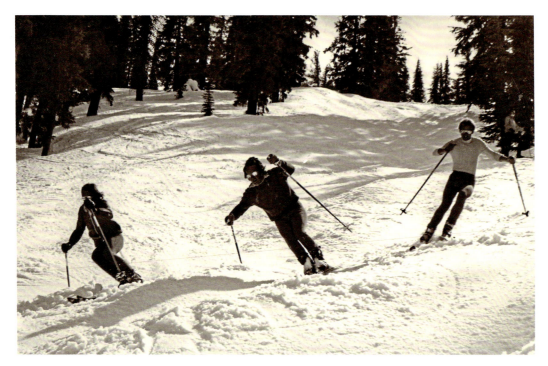

SQUAW VALLEY ALPINE SKIING: Mining, cattle ranch, hay field, Winter Olympics site, and destination winter resort. All describe magnificent Squaw Valley and its sister ski resort, Alpine Meadows. These intrepid snow skiers are about to brave a Black Diamond-rated trail starting at over 9,000 feet in elevation. Second only to Heavenly Valley in the number of chairlifts, the area offers forty-three chairlifts and 62,000 acres of world-class skiing. (T:PLACER) (B:MS)

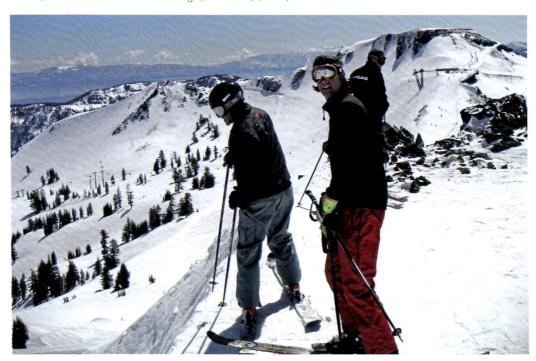

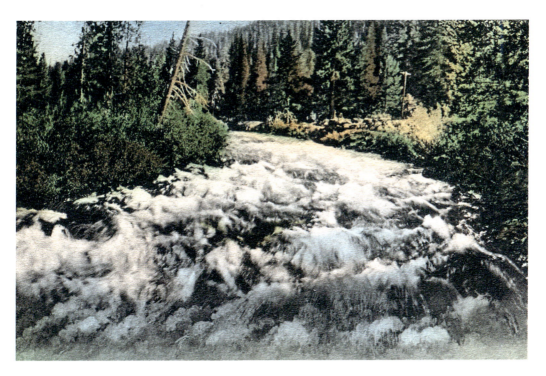

TRUCKEE RIVER AND RAFTING: Water cascading down the Truckee River from Lake Tahoe's one outlet is captured by this 1906 hand-colored image. Note the locomotive *Glenbrook* traveling alongside. In full spring flood, the river provides a great raft ride for this father-and-son duo. Rafters launch in Tahoe City and spend the day on the river, exiting at River Ranch to well-deserved hamburgers, french fries, and margaritas.

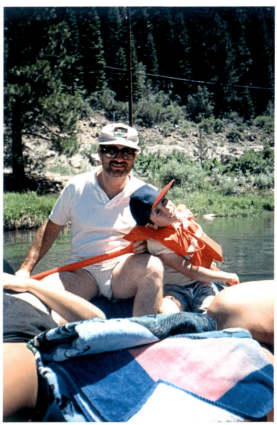

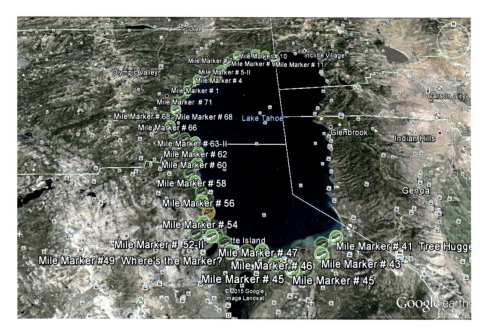

CIRCUMNAVIGATING AND GEOCACHING: Thanks to Placer and El Dorado counties, highway markers are placed every mile along the California shore of Lake Tahoe. Follow these distinctive markers clockwise around the Lake and note the points of historic interest as you travel. Images located near mile markers are indicated in the corresponding captions throughout this book beginning at Tahoe City with mile marker zero (MM#0). For more fun, try Geocaching (NevadaGeocaching.com). (T: Google)

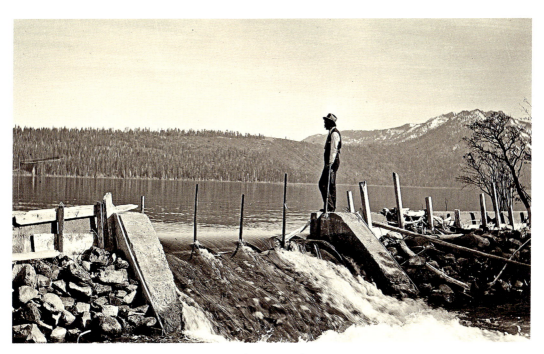

TRUCKEE RIVER DAM AND OUTLET (MM#0/72): Successive dams have been built at Tahoe City to raise the Lake above the natural 6,223' elevation water level. By current law, the maximum lake level can be increased artificially another 6.1'. Flow levels are controlled by Reno, Nevada, which looks to Lake Tahoe as its primary water supply. The 2015 drought finds the lake surface three feet below its natural level.

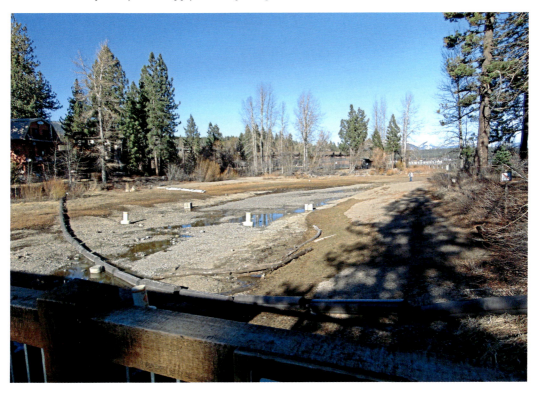

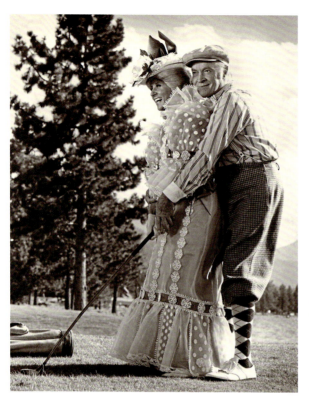

GOLF AND RECREATION:
The Tahoe Tavern Golf Course, now the Tahoe City Municipal Golf Course, began as links in the Scottish St. Andrews course tradition. Bob Hope and Sandra Palmer spoof these good old days. Contemporary Tahoe City golfers are likely to find their course returning to its original 1917 rough, brown links with nine green holes as Tahoe suffers from a multiyear drought. (T:NHS) (B:NLTHS)

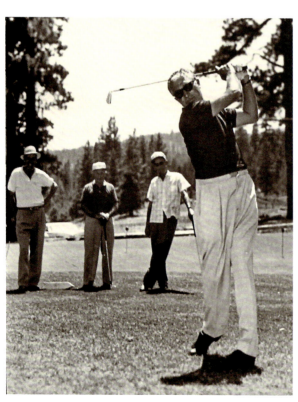

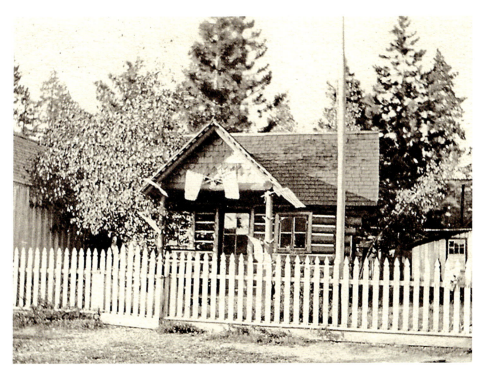

WATSON CABIN (MM#1): Longtime resident and first Tahoe City constable, Robert M. Watson (1854-1932), built this cabin in 1908 as a wedding present for his son, Robert H., and his bride, Stella Tong. The cabin is listed today on the US Register of Historic Places and is maintained as a living history museum for the North Lake Tahoe Historical Society (northtahoemuseums.org). (T:DD)

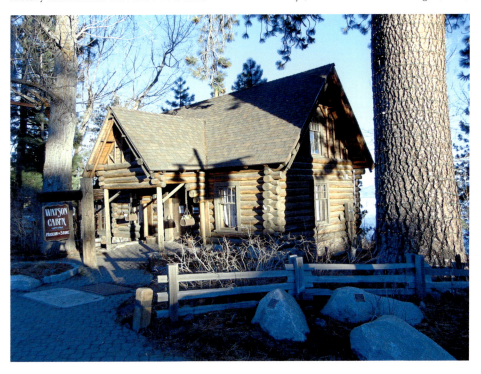

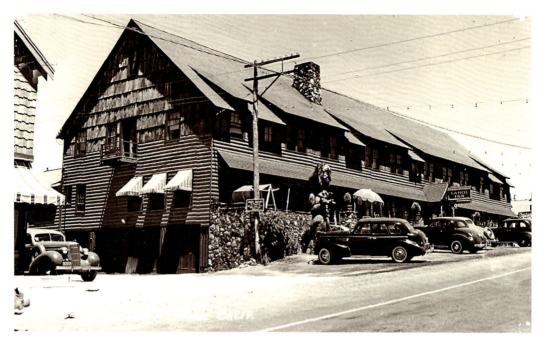

THE TAHOE INN AND BECHDOLT BUILDING, TAHOE CITY: The original building on this site was home to D. L. Bliss, who sold it to Robert M. Watson who then ran it with his wife, Sarah Cunningham, and their children. The Watsons called it the Tahoe Inn: hotel, restaurant, and bar. It was sold and continued in business under Carl A. Bechdolt's ownership until a fire consumed it in 1934. The inn was rebuilt immediately. In 2015 we know the Bechdolt Building for its prime tenant, the Blue Agave Mexican restaurant. (T:DD)

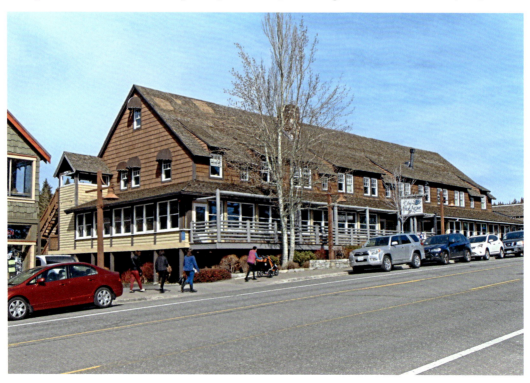

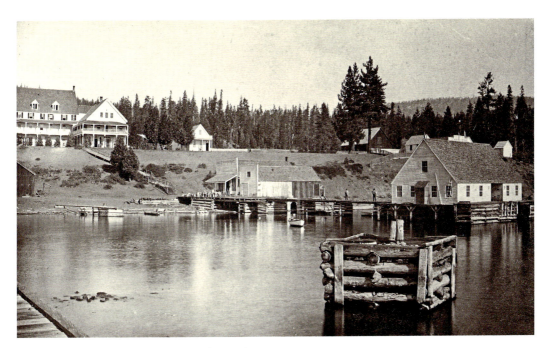

Tahoe City from The Lake (MM#1): The eighty-four-room Grand Central Hotel was the featured building and center of Tahoe City life from 1871 to 1894, when it catered to travelers between the Comstock Lode mining interests, local timber claims, and San Francisco headquarters. Today, the same location houses the Blue Agave restaurant, the SS Tahoe Gal dock, and Tahoe Yacht Club facilities. (T:PLACER)

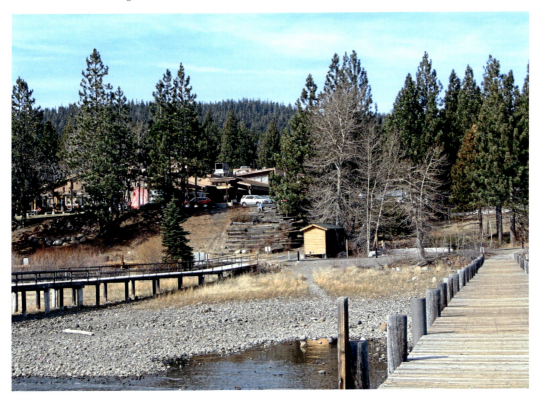

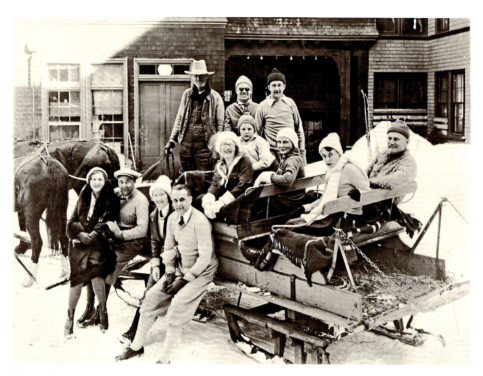

SNOW SLEIGHING: "Sledding through the snow in a one-horse open sleigh" was an immediate favorite winter sport at the Tahoe Tavern when the resort first opened year-round to include winter lodging in 1928. We still experience sleigh rides today, but use retractable wheels to accommodate low snow levels, as shown by this early February 2015 image from Sand Harbor, Nevada.

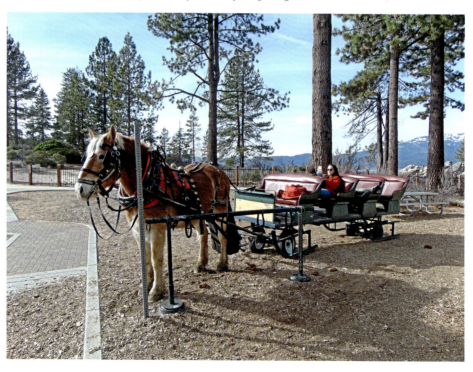

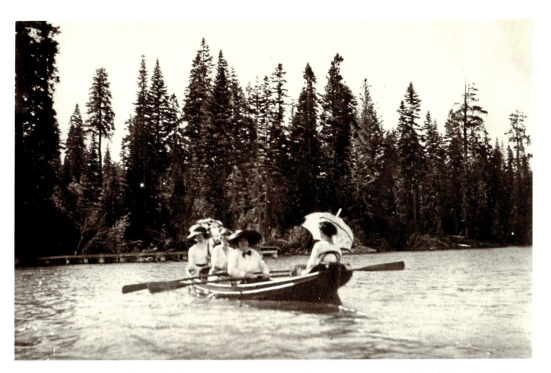

ROWING AND STAND-UP PADDLEBOARDING: "Believe me, my young friend, there is nothing – absolutely anything – half so much worth doing as simply messing about in boats. Simply messing," he went on dreamily: "messing – about – in – boats; messing–" *The Wind in the Willows* (1908) by Kenneth Grahame. Both parties, one rowing a traditional lapstrake whitehall rowboat and the other enjoying the modern stand-up paddleboard, agree completely. (T:NLTHS)

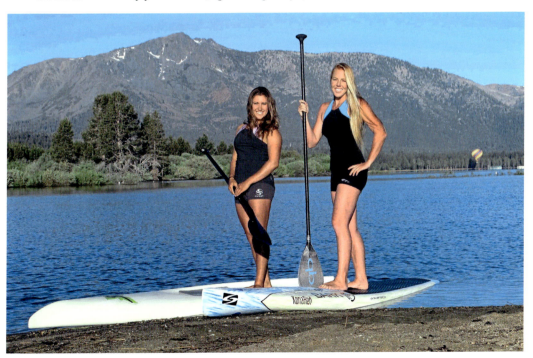

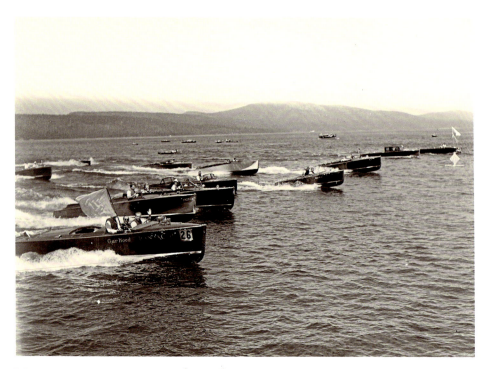

WOODEN BOATS AND SAILING (MM#6): The Tahoe Yacht Club has sponsored local boating regattas and events since 1925. Initially, the club held summer speedboat races featuring friendly rivalries between Stanley Dollar and Henry Kaiser entries. In 2015 the club offers a wide variety of watercraft programs. They include youth sailing, weekly fun competitions, rowing races, the Trans Tahoe sailing race, and the Concours d'Elegance of wooden boats. (T:NLTHS) (B:HP)

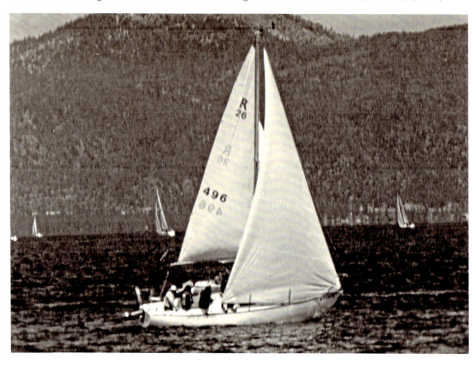

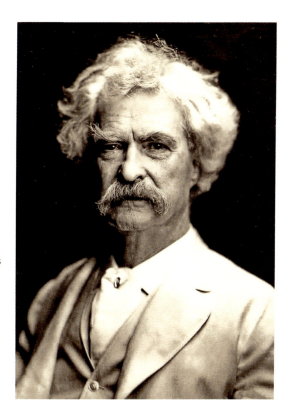

MARK TWAIN (MM#8): "The Fairest Picture" for Samuel Clemens was his first sight of Lake Tahoe, as he describes in letters home and as Mark Twain in *Roughing It* (1872). Our *Territorial Enterprise* cub reporter camped and located a timber claim on the Lake's north shore. For twenty-five years, McAvoy Layne, as the ghost of Mark Twain, has kept Samuel Clemens' experience alive with local and national living history renditions of the wit and wisdom of America's favorite novelist. (B: ML)

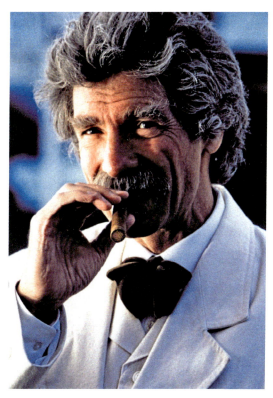

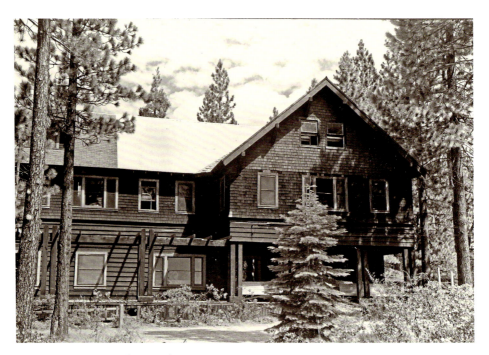

BROCKWAY SPRINGS (MM#10): Brockway Springs Resort in Kings Beach, founded in 1869, is one of the oldest resorts along Tahoe's shoreline. Its hot springs attracted native Washoe, timbermen, miners, religious seekers, and tourists all in turn. The resort became the Brockway in 1900 when acquired by Fred Alverson; later, it was purchased by the Comstock family. Today, it is a private, gated community of lakefront residences and condominiums. The hot springs are still there. (T:KP)

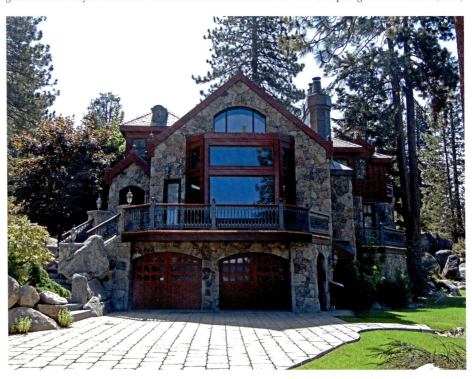

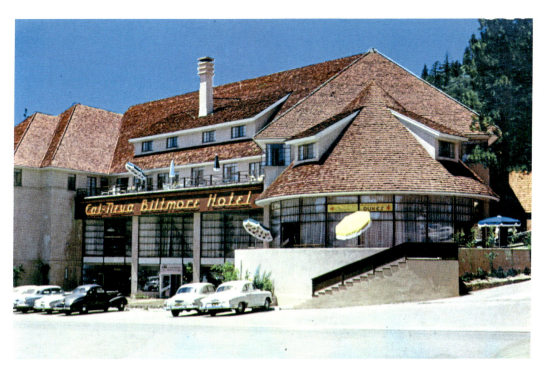

THE BILTMORE, CRYSTAL BAY, NEVADA (MM#11): The Tahoe Biltmore Lodge and Casino at Crystal Bay, Nevada, opened shortly after Cal-Neva and maintains its clientele today as the only major casino open on the north shore of Lake Tahoe. It draws crowds with additional attractions such as bocce ball tournaments and Nevada's ever-attractive marriage laws.

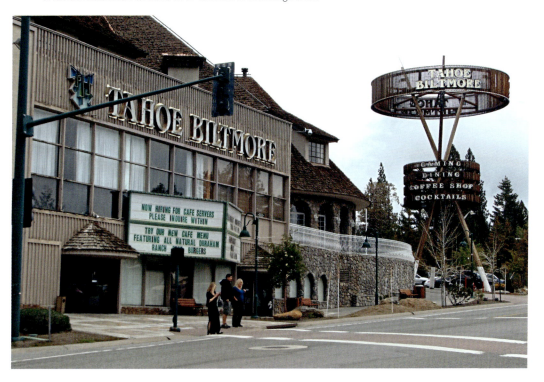

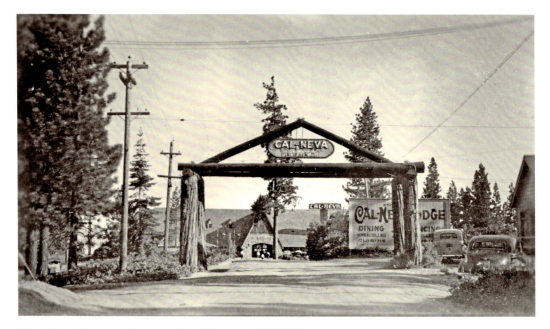

CAL-NEVA LODGE, CRYSTAL BAY, NEVADA (MM#11): In 1927, the Ta-Neva-Ho casino opened at Crystal Bay, inches into Nevada from the California State line. The Cal-Neva casino was subsequently built at the same location by Bob Sherman and has had a series of famous and sometimes infamous owners to date. The Frank Sinatra ownership period had legendary guests: Marilyn Monroe, Rat Packers, and underworld characters. The property is once more undergoing a transformation in 2015 and will open under new management soon. (T:NHS)

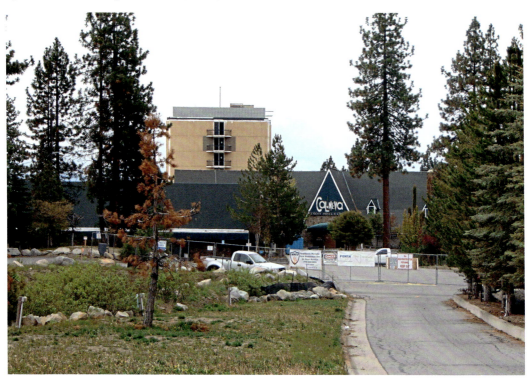

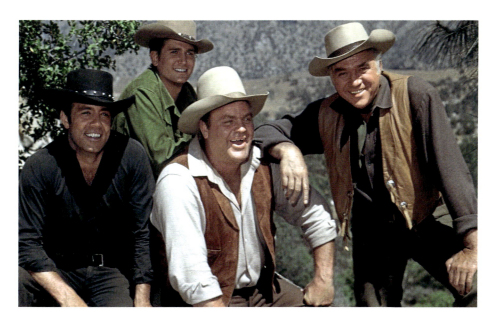

PONDEROSA AND TELEVISION, INCLINE VILLAGE, NEVADA: The *Bonanza* television program (1959-1973) features the fictional Cartwright family and their lives on the Ponderosa Ranch. The popular western program was set on the grand-scale site of the Hobart and Marlette Sierra Nevada Wood & Lumber Company. The popular locally owned, western-themed park with a tie-in to NBC drew crowds until 2004, well past the original program heyday and lives of most of the original cast members. (B:NHS)

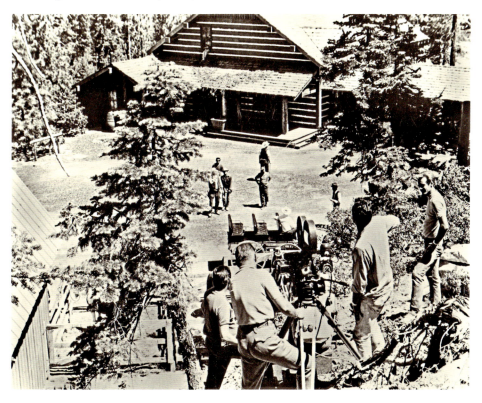

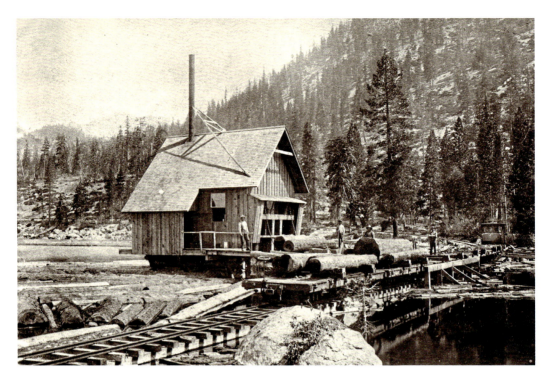

SAND HARBOR AND SHAKESPEARE, NEVADA: Sand Harbor is one of the few warm and sandy beaches along the east shore of Lake Tahoe. The natural harbor and its location made it easy to load timber that was boomed across the lake and ready for transport up the 1,400' vertical and 4,000' long Incline Railroad. In 2015 Sand Harbor State Park hosts an annual summertime Shakespeare theater featuring a professional acting troupe from Nevada City, California. (T:NHS) (B:NHS)

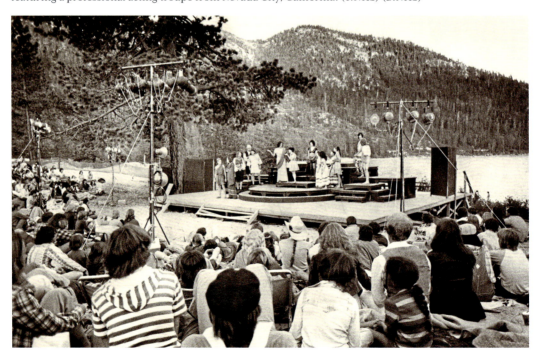

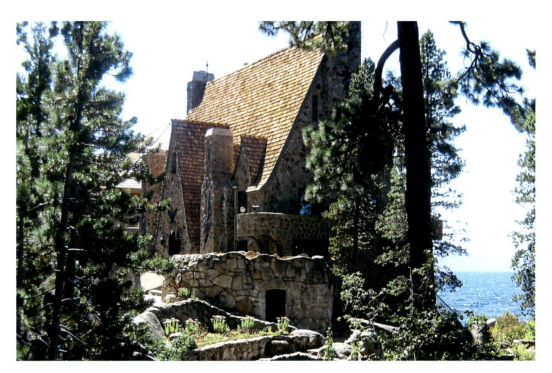

THUNDERBIRD LODGE, NEVADA: We have a lot to thank George Whittell, Jr., for – he purchased essentially the entire "timber-spent" Nevada Lake Tahoe watershed from D. L. Bliss heirs in the early 1930s. Eventually, Whittell owned twenty miles of shoreline and 40,000 acres of land, all posted with "Keep Out!" The Thunderbird Lodge, completed in 1939, was his home until his passing in 1969. The lodge, a speedboat prototype for the famous WWII PT boats, and the unspoiled East Shore are his lasting legacy.

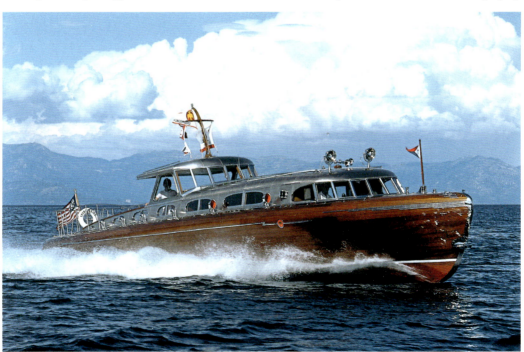

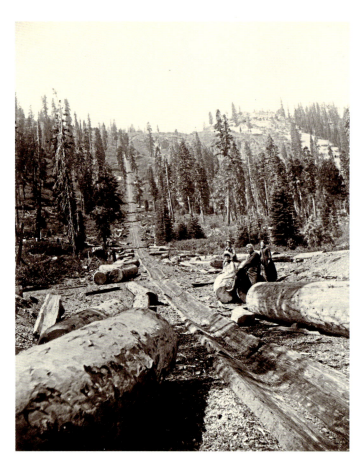

RIDING THE FLUME:
Today, off-road bicyclists love the thrill of pedaling along nineteenth-century ribbons of dry and wet "V" flume scars crisscrossing forestlands. Wood-lined sleeves or flumes moved clear-cut timber for miles under their own gravity-fed momentum before splashing into the lake. Once boomed, milled, and team-transported to the crest of the Sierra, wood was carried through water-lined "V" flumes down the mountain toward Virginia City's mines.

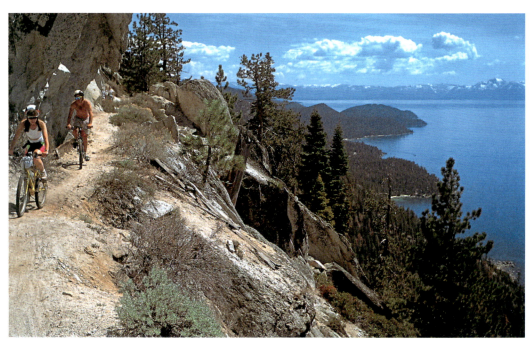

SNOW PLANTS AND FLORA: The first indication of spring at Lake Tahoe is the snow plant (*Sarcodes sanguinea*) in the Indian-pipe family (*Monotropaceae*), and closely related to the Heath (*Ericaceae*) family. This true perennial, vascular plant eschews green chlorophyll for red, disdains photosynthesis, and is not a fungus. It relies on its symbiotic relationship with underground fungi associated with conifers. You will find it in or near pine needles, growing occasionally as tall as 12". (B:MP)

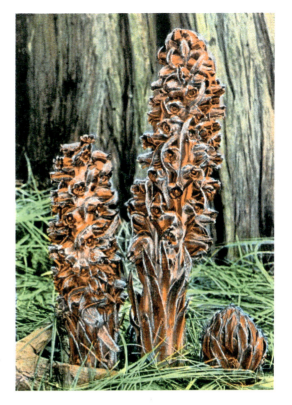

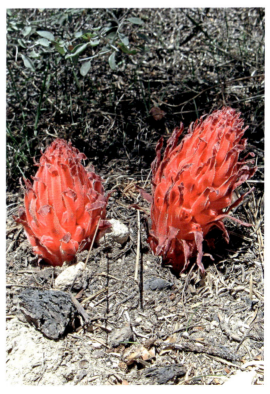

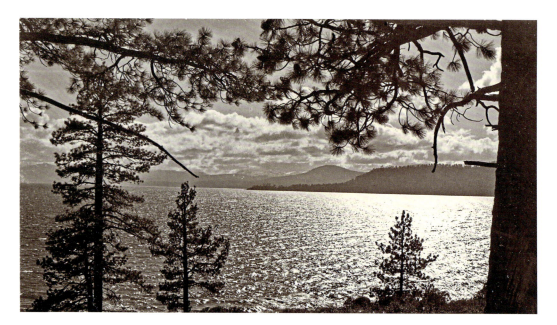

TRANQUIL EAST SHORE: The east shore of Lake Tahoe has remained undeveloped since its timber-cutting and lumber-milling days. George Whittell, Jr., sold his property at Incline Village hoping to appease developers and concentrate population there and away from his 40,000 acre personal nirvana centered at the Thunderbird Lodge. Visitors seek out unmarked trails leading to granite rock-littered private, occasionally clothing-optional, beaches and boulders. Skunk Harbor and Secret Beach are favorites.

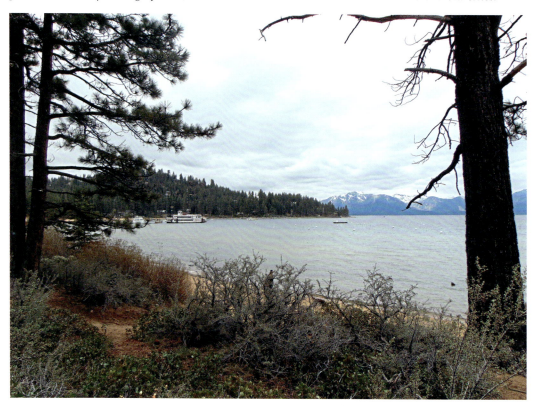

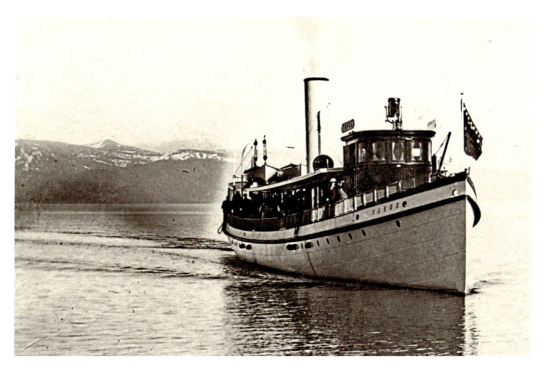

SS Tahoe **and** *MS Tahoe Queen:* Every dollar destined for the hospitality industry at Lake Tahoe was intercepted from 1886 to 1920 by a fare paid on the Bliss-owned steam launch, the *SS Tahoe*. Built in San Francisco and launched at Glenbrook in 1886, it delivered all tourists and US mail arriving at Tahoe City to their resort destinations around the lake. It was scuttled in 1940 only to be replaced in 1983 by the modern excursion sternwheeler, the *MS Tahoe Queen*. (T:KP)

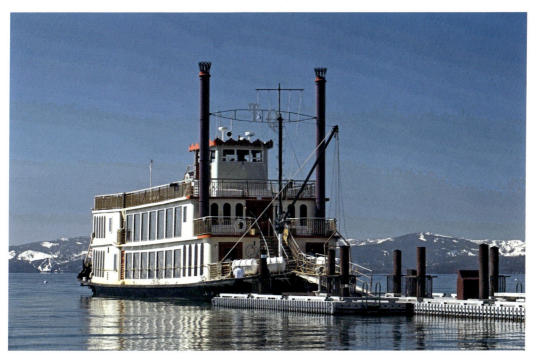

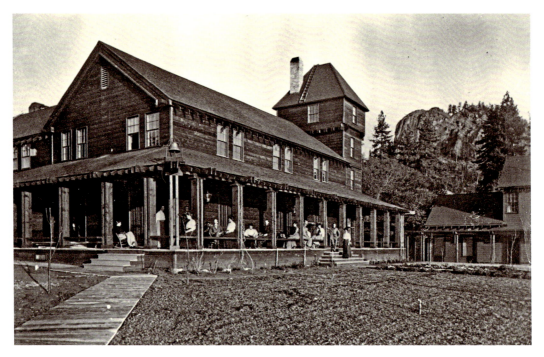

GLENBROOK, NEVADA: The community of Glenbrook, established in 1878, was the first true settlement on Lake Tahoe. It was soon identified with Duane L. Bliss (1835-1910) and the center of the Carson and Tahoe Lumber & Fluming Co. operations. The decline of the Virginia City and Comstock Lode mines transformed Glenbrook into a resort destination, which opened to guests in 1907. Do you recognize this famous guest staying at the hotel while awaiting his Nevada divorce? The hotel closed in 1976 and in 2015 Glenbrook is a private residential home compound. (T:LTHS) *Answer: Clarke Gable*

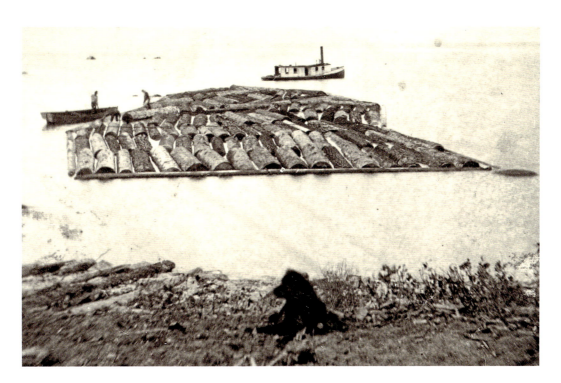

BOOMING TIMBER AND FLUMING LUMBER: Once the massive ponderosa pines, sugar pines, red cedar, and Douglas-fir were clear-cut from the west and south Lake Tahoe Basin, they were boomed and transported for milling. This tugboat is guiding timber from the Bijou train pier to Glenbrook for milling. Once milled, the lumber was transported by locomotive to the top of Slaughterhouse Canyon and jettisoned to Carson Valley, Nevada, via a V-shaped water flume. (T: LTHS) (B: LTHS)

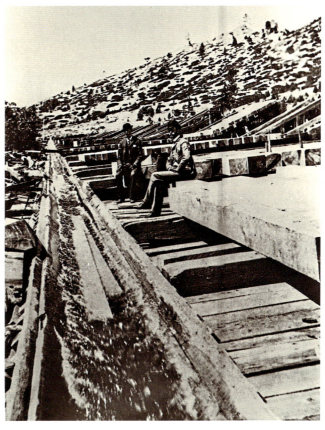

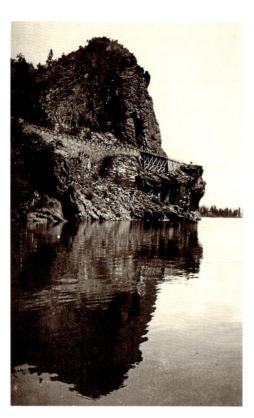

THE LADY OF THE LAKE: The nineteenth century was a very romantic and literary age. Natural geologic features were anthropomorphized (pareidolia) into familiar faces, characters from literature, and famous people. Shakespeare Rock, Granite Chief, Old Man of the Lake (tree stump), and Our Lady of the Lake are four landmarks sought out and remembered in the twentieth century. Take a virtual trip back in time and see if you can find them. (T:DD)

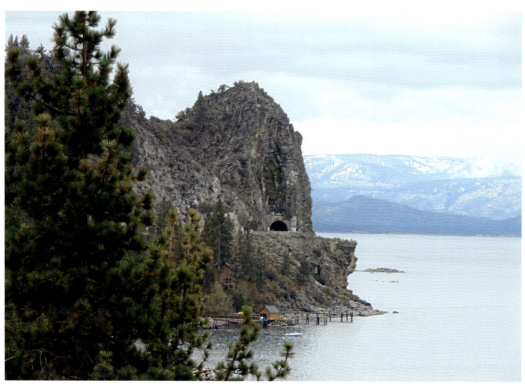

CAVE ROCK, NEVADA: The natural cave(s) found in this igneous, volcanic pluton or "thumb" provided the last obstacle to continuous surface road travel around Lake Tahoe. A natural and appealing geologic feature, Cave Rock features in Washoe sacred lore and as summer shelter. The single highway bore was drilled in 1931 as part of the development of the Lincoln Highway, which is modern-day Highway 50. The tunnel replaced the earlier "road" – a hanging bridge along the rock wall. (T:NHS)

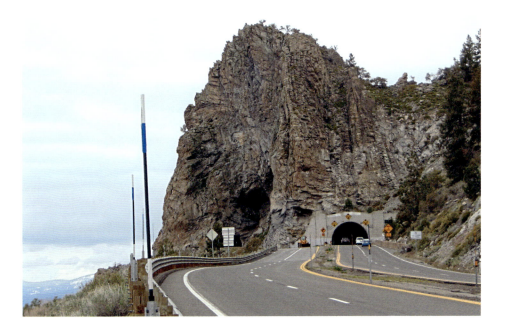

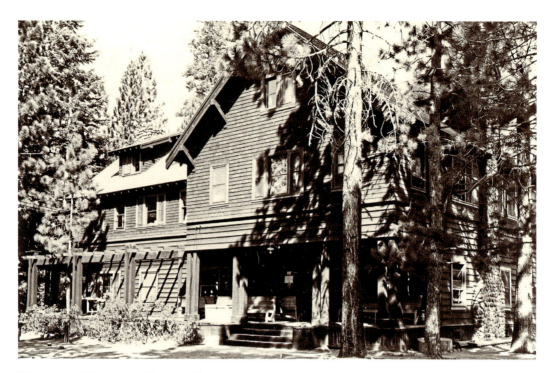

RELIGIOUS RETREAT, ZEPHER COVE, NEVADA: Lake Tahoe has a long history of religious retreats, dating back to the Nevada itinerant ministry of George Wharton James. Numerous Christian denominations acquired reasonably priced, "worthless" timber resource land along the shore for their retreats. The California and Nevada Presbyterian Churches acquired the thirty-six acres of Zephyr Cove in 1924 as a Presbyterian Youth Conference Center. The conference grounds are still available for both secular and religious meetings today. (T:KP) (B:NHS)

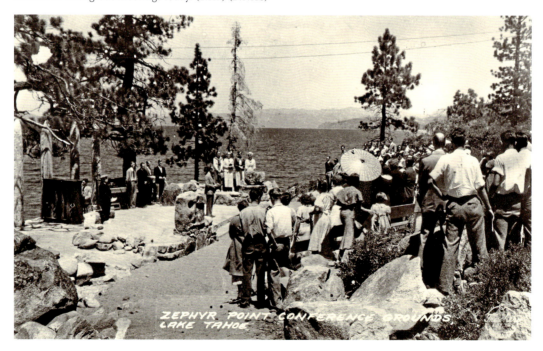

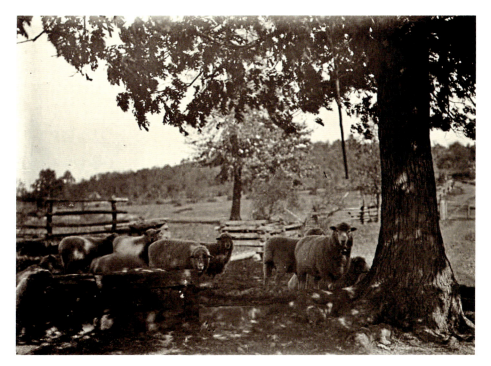

SUMMER CATTLE PASTURAGE: Seasonal grazing of cattle and sheep has been controversial in the Tahoe Basin for over 100 years. Debate began with the creation of the Lake Tahoe Forest Reserve in 1895 by President Theodore Roosevelt. With this action, timber culture laws were revoked and commercial use of timbered or underbrushed land were set aside as public lands. The debate about how traditional range rights apply to the Forest Reserve continues today. (T:LOC) (B:NHS)

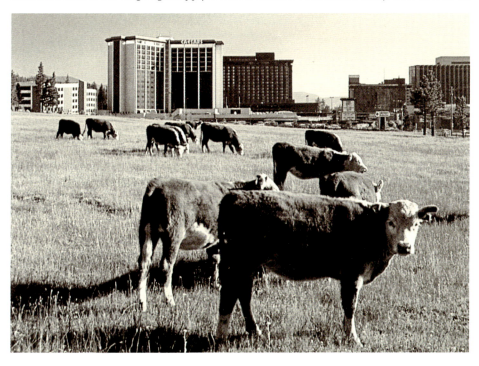

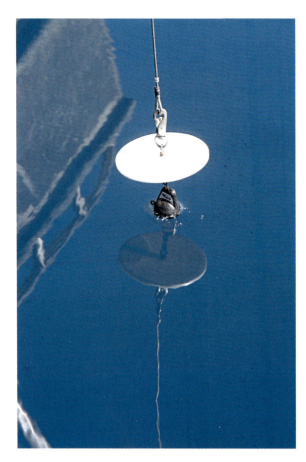

LAKE TAHOE CLARITY: Lake Tahoe water clarity defines the Lake of the Sky. Samuel Clemens thought he could touch granite rocks and trout 100' below the lake surface as he lolled in a rowboat near Crystal Bay. The University of California at Davis has been monitoring and promoting water quality since it first lowered the Secchi disk into Lake Tahoe in 1968. Today, visibility is limited to 77.8 feet according to 2014 measurements.

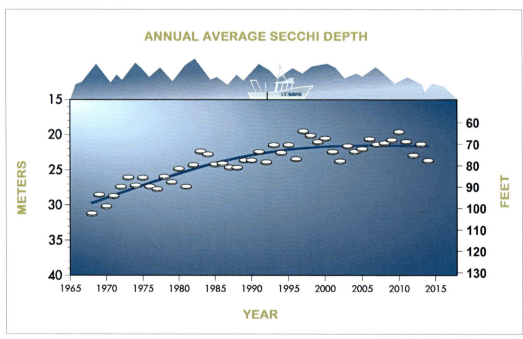

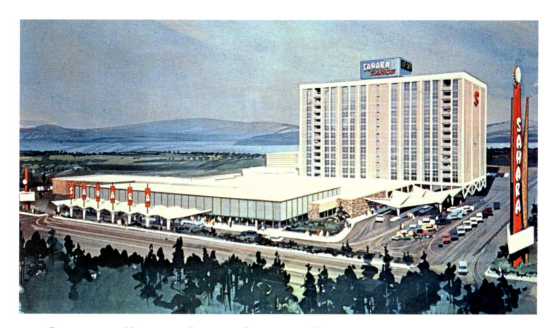

SAHARA AND MONTBLEU RESORTS, STATELINE, NEVADA: Park Tahoe, quickly renamed Sahara, opened in 1978 and was the last of the major stateline casinos to open at South Shore. It was leased and renamed Caesar's Tahoe one year after its opening. The luxury casino and hotel line continued for thirty-five years until 2005, when the property was sold to the gaming competition across the street, Horizon Casinos. Rebranded as Montbleu, the property is owned by Tropicana Entertainment in 2015.

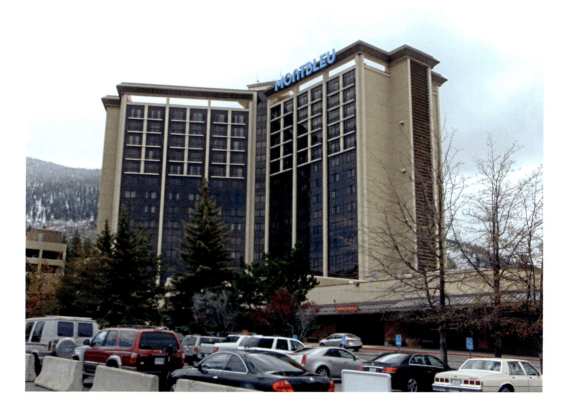

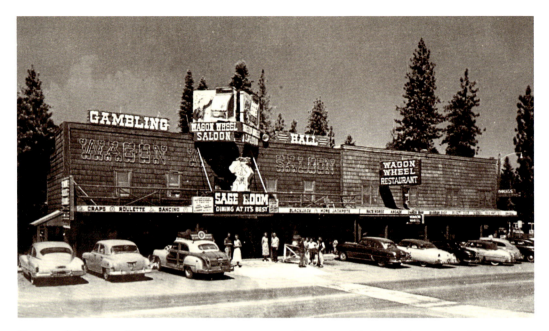

HARVEY'S WAGON WHEEL SALOON, STATELINE, NEVADA: "Nothing is better than Nevada beef," said butcher and wholesaler Harvey Gross. To which he might have added, "… and a casino." Harvey and Llewellyn Gross expanded their butcher operation into a South Shore casino in 1944. They expanded again when they moved their operation to Stateline in 1956. The landmark, family-owned restaurant and casino added hotel accommodations in 1963. In 2015, Harvey's is part of the Harrah's Entertainment Corporation. (T:NHS)

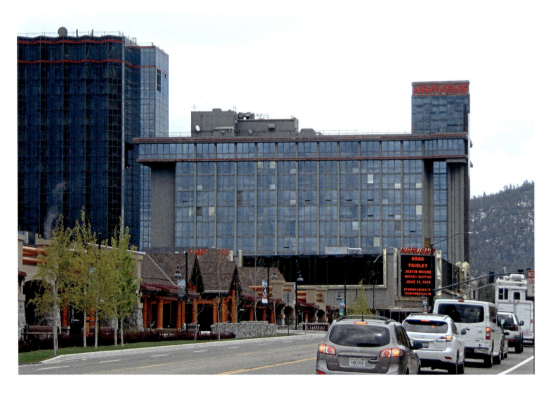

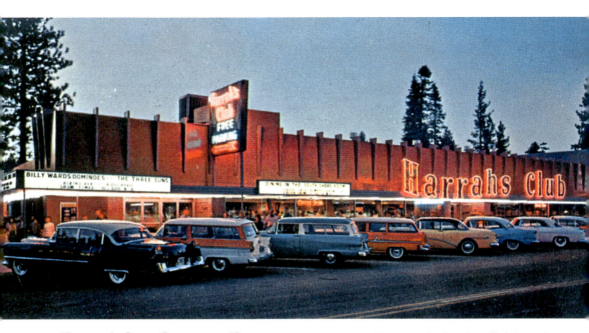

HARRAH'S CLUB, STATELINE, NEVADA: Bill Harrah opened his Harrah's Stateline Club in 1958 after selling his Lake Club interest to Harvey Gross. Harvey and Bill would dominate Stateline Lake Tahoe adult entertainment for the next twenty years. Harrah's South Shore Room still features the finest entertainment north of Las Vegas. In 2015, Caesar's Entertainment Corporation owns Harrah's.

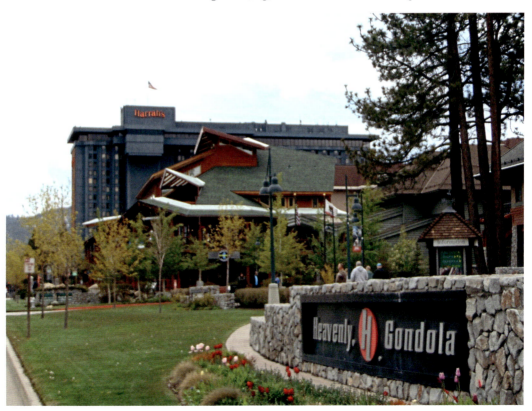

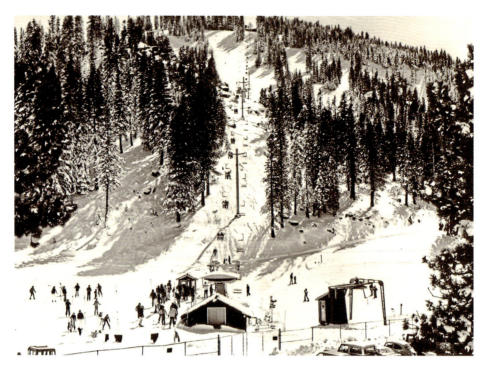

HEAVENLY VALLEY SKI RESORT, SOUTH LAKE TAHOE, CALIFORNIA: Heavenly Valley was the first major downhill ski resort with modern chairlifts in the Lake Tahoe area. Alpine skiing became popular after WWII. Beginning in 1955, a series of partnerships and owners grew Heavenly into the largest ski area in the United States by 1967. World-class ski racing has been the resort's hallmark ever since, as skiers plummet "Down the Gunbarrel!"

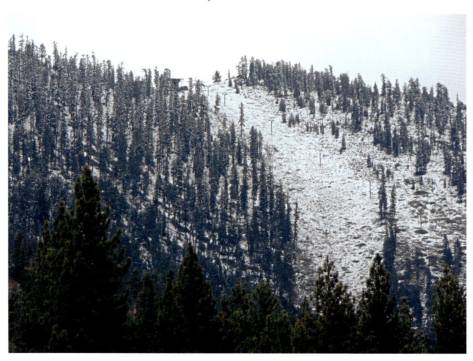

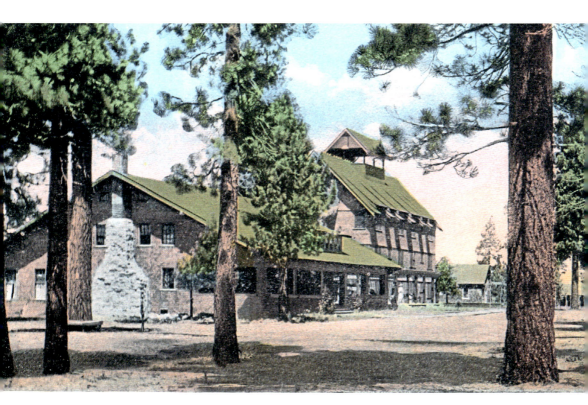

AL TAHOE, SOUTH LAKE TAHOE, CALIFORNIA (MM#42): Many hamlets comprise today's incorporated city of South Lake Tahoe, California. Each community has a unique identity and often has dedicated, returning summer guests. Each resort was geographically separate from its closest competitor. Al Tahoe Hotel and post office were named (after himself) by Almerin R. Sprauge, who built a summer resort hotel along the south shore in 1907. No Hollywood-style sign exists today to help you find it.

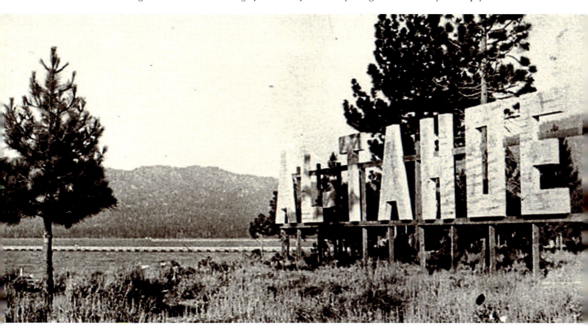

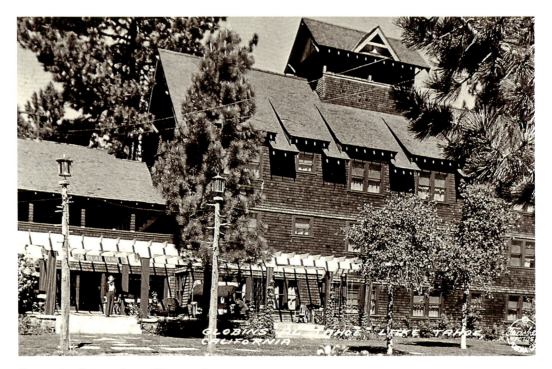

GLOBIN'S, SOUTH LAKE TAHOE, CALIFORNIA: You can still find Al Tahoe if you look carefully along State Highway 50 for the Globin's Building that houses a laundromat. Frank Globin bought the Al Tahoe Hotel from Almerin Sprauge in 1924. A beautiful, long, sandy beach, hotel, cabins, and water sports ensured the hotel's long popularity. Globin's Al Tahoe Resort closed in 1968. The beach is now the very popular and the first public beach as one arrives at the lakeshore on Highway 50 from the west. (T:DD)

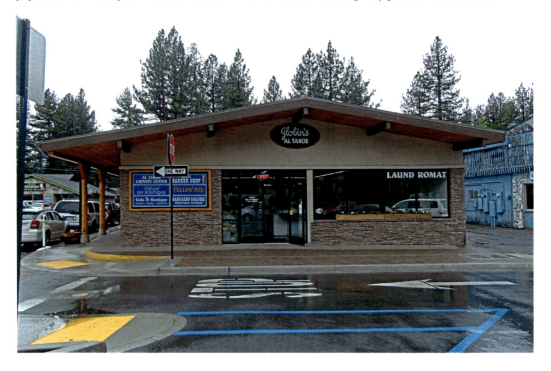

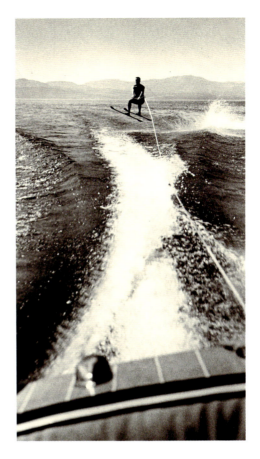

WATER SKIING: Ralph Samuelson of Minnesota invented water skiing in 1922. The sport's introduction was thanks to the powerful boats motorized by internal combustion marine engines. These beautiful wooden boats were invented in the mid-1910s and could lift a person onto the surface of the water. Water skiing first gained popularity in California in the Sacramento and San Joaquin River Delta thanks in great part to the Stephens Brothers Boat Works in Stockton. These boats, along with Gar Wood boats from the Midwest, ensured the continued popularity of the sport. (T:NHS) (B:MS)

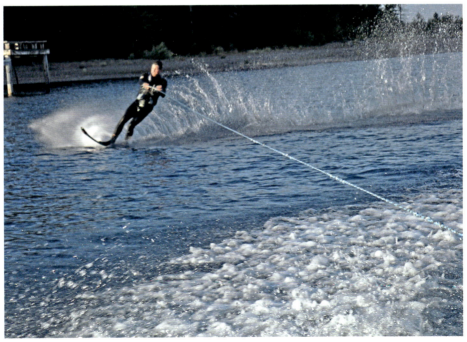

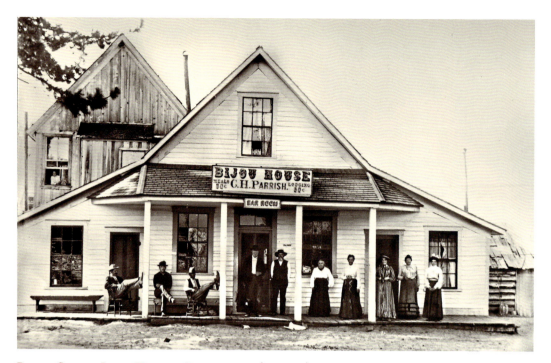

Bijou, South Lake Tahoe, California (MM#41): Bijou's original distinction was as the closest lake embarkation point for timber brought north by train from Lake Valley. D. L. Bliss timber operations transported logs by narrow-gauge railroad to the Bijou pier, offloaded them into the water, boomed them, and transported them to the Glenbrook lumber mill. The closing of the Comstock mines diminished the commercial value of the area's timber resources. At this turning point, the Young Brothers established a hostelry at Bijou to take advantage of the area's fledgling tourist industry. (T:NHS)

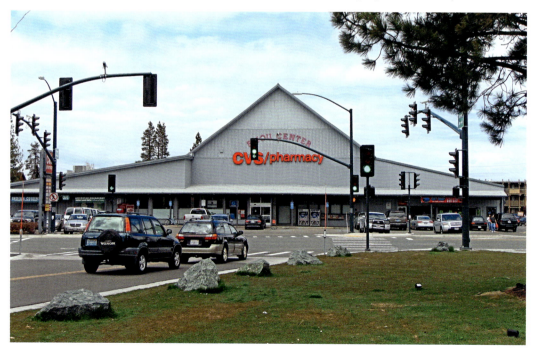

EDUCATION COMMITMENT (MM#43): South Lake Tahoe's first school was located at Lake Valley. It served all elementary-age children south of Emerald Bay. A high school was established in the area in 1952. Post-secondary education in Tahoe began in 1975 with the creation of Lake Tahoe Community College. Its original classes were taught in a local motel to a minimal student population. Today, the college boasts year-round classes, a 164-acre campus, and over 2,500 students enrolled each academic term. (T:LTHS)

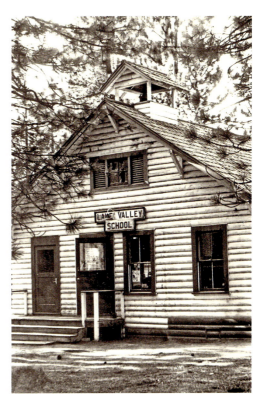

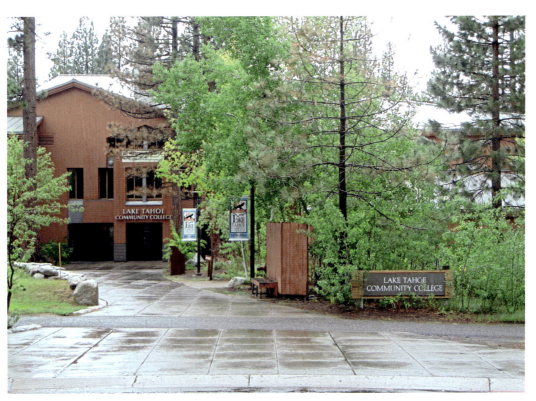

SUMMER CAMP AND THE "Y", NOW THE "X", SOUTH LAKE TAHOE, CALIFORNIA (MM#44): A series of camps and vacation spots were located between the "Y" and Meyers Station. Camp Tawonga was established here in the early 1920s. It was the first Jewish overnight camp for San Francisco children, and was sponsored by the Young Men's Hebrew Association. In 1942 the camp was discontinued because of WWII and the land was sold. It is now the location of the South Lake Tahoe Airport.

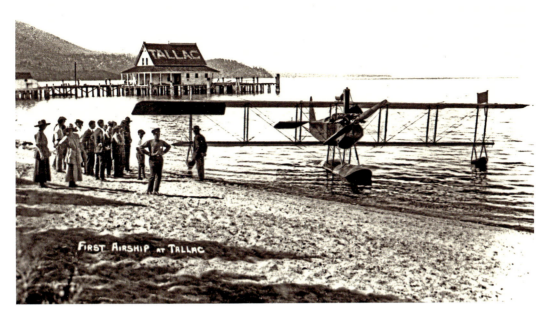

AVIATION: The first plane in Lake Tahoe landed on the lake at Lucky Baldwin's Tallac House. This was a feat, as navigating the Sierra Nevada meant following the passes, keeping a proper oxygen/fuel mixture while changing altitude, and, of course, not running into any mountains. Planes landing at South Lake Tahoe's first and still only airstrip today have the same challenges. Tahoe Valley Airport began accepting commercial flights in 1963. Turbo prop aircraft like this Transamerica Airline plane flew the Tahoe skies until 1983. Commercial jet aircraft served Tahoe until 2000, when commercial flights to the airport were discontinued. (T:LTHS) (B:LTHS)

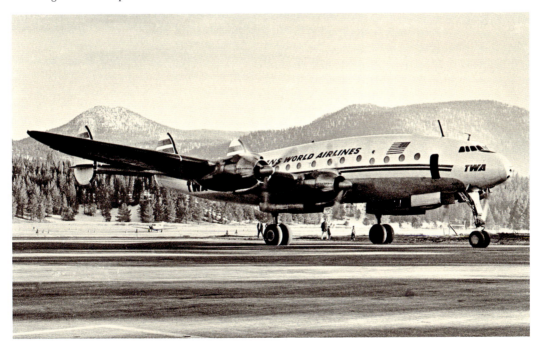

JOHNSON'S PASS, MEYER'S GRADE, ECHO SUMMIT, AND HIGHWAY 50: Personal vehicles supplanted railroad and steamship travel in the 1930s. Johnson's Pass and toll road were integrated into the US highway system. Highway 50 was graded, paved, and improved, making travel to South Lake Tahoe and the casinos very easy. Winter access became possible as local businessmen wielded the snow shovels and manually cleared Echo Pass. Major rerouting and widening of the highway in the early 1960s created the route we travel today.

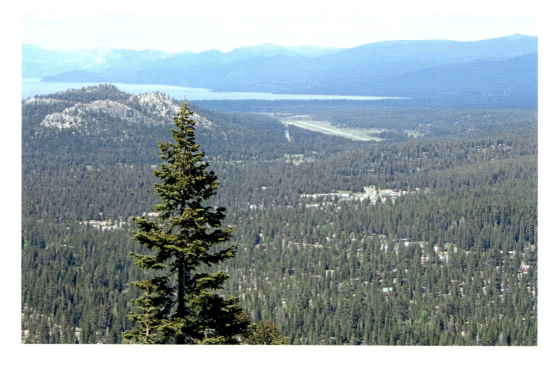

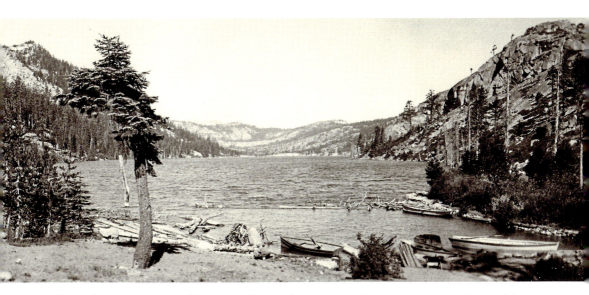

ECHO CHALET AND THE UPPER AND LOWER LAKES: Every backpacker has taken the "whale" water taxi from Echo Chalet, traveling through lower and upper Echo Lakes to begin hiking into Desolation Wilderness. There has been a series of boat concessions established at Echo Lakes, beginning with Hamden Cagwin's, which operated from 1897 to 1914. Ralph King's Boat Services began in 1927 and offered water taxi services. In 1938, Echo Chalet Store was built and the new owners started offering the expanded boat services that are still enjoyed today. (T:DD)

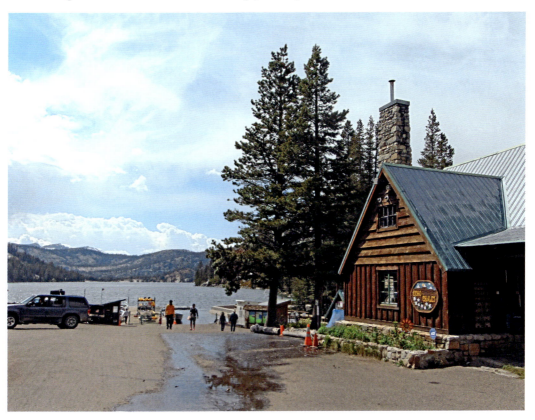

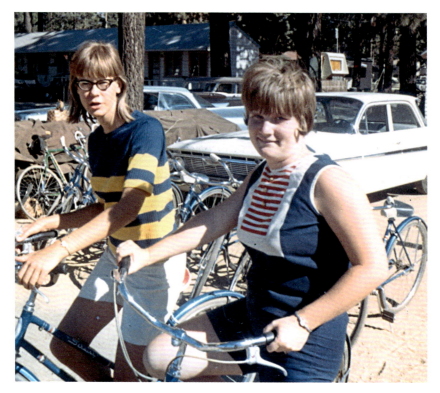

BICYCLING (MM#45): Anderson's Bike Rental located at South Lake Tahoe has been renting bikes for over fifty years. They are pre-bike path, pre-cool, pre-adult bicycle enthusiasts. These two teenagers could represent "now," but they are having an adventure "then" *circa* 1963. Those halcyon, pre-Vietnam War days of fifty years ago are now history.

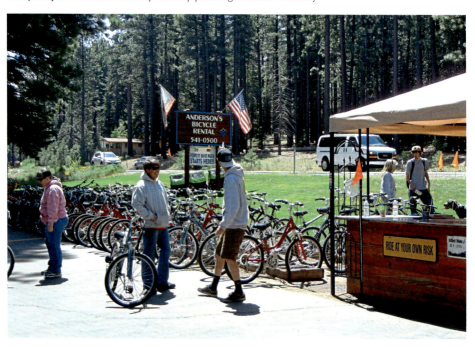

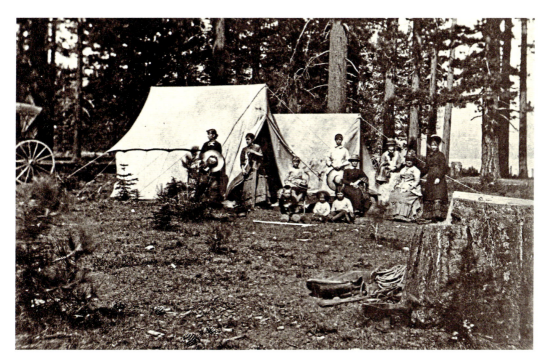

CAMPING AND THE MOTOR HOME (MM#47): In recent years, the Gene and Kelly Brown family has enjoyed their family vacation staying in a motor coach at Richardson's Resort. Their grandparents began this tradition camping at Richardson's in tents over eighty years ago. They are no exception. Families have been dedicating themselves to Lake Tahoe and their preferred camping or hostelry since the end of the Comstock period, when Tahoe's resort economy was just beginning. Boxes of family photo albums attest that, "We will see you again next year!" (T:NHS)

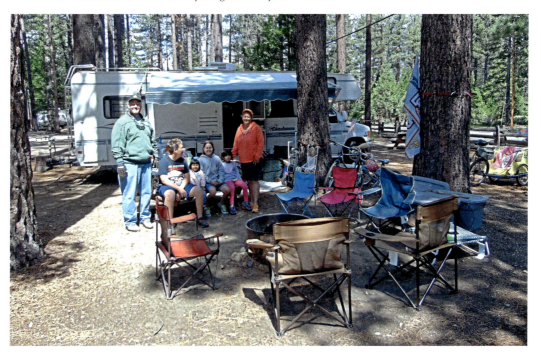

SOCIETY AT PLAY (MM#48) – FALLEN LEAF LAKE AND TALLAC: Elias "Lucky" Baldwin (1828-1909) acquired Yank's Station, just south of Taylor Creek, in 1878. Baldwin loved the area and his "luck" extended to saving the local Jeffrey pines from the lumberyard. His daughter, Anita Baldwin (1876-1939), inherited the property and summered at Fallen Leaf Lake. Her daughter, Dextra Baldwin (1901-1967), continued the summer living tradition at her home, which is now part of the Tallac Historic Site.

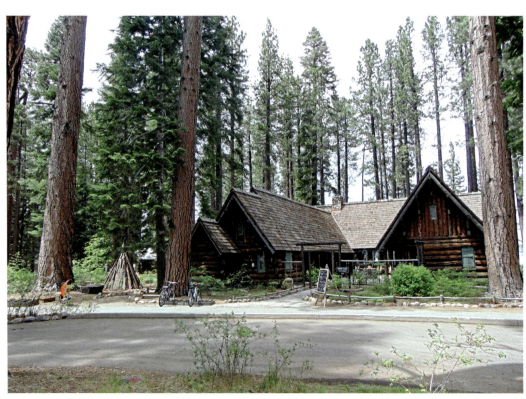

Native Americans – Washoe People:

The Washoe people are the indigenous, Native American tribe that lives in the Great Basin, primarily in the Carson Valley and the Sierra Nevada. They are historically associated with summer living at Lake Tahoe. Sustained contact between the Washoe people and Europeans began with the California Gold Rush. The decimation of the pine forests used in the Comstock Lode marginalized the Washoe. Today, the Washoe Tribe of Nevada and California assumes an increasingly important cultural and economic role in the Reno/Tahoe region. (T: LTHS) (B: WASHOE)

Menu

Sunday August 20th 1911 — Tallac
Consommé Bellevue
Cream of Scrabin à la Baltimore
Olives, Pickles, Chow Chow
Baked Lake Trout, Andalouse
Sliced Cucumbers, Potato Duchesse
Broiled Short Rib of Beef au Bernaise
Braised Calf's Sweet Breads, Macédoine
Fricassee of Chicken Sweet with Spaghetti
French Pancakes, Currant Jelly
Roast Prime Rib of Beef au Jus
Roast Young Turkey, Cranberry Sauce
Mashed Potatoes, Candied Sweet Potatoes
New Corn in Cream, String Beans
Fruit Salad Secret
Lettuce with Egg, Mayonnaise or French dressing
Dessert, Napoleon Slices, Custard Pie
Chocolate Ice Cream, Assorted Cake
Watermelon, Peaches, Oranges
Nuts, Raisins, Coffee, Tea, Milk
Buttermilk, American, Limburger Cheese

FINE DINING (MM#46): Lucky Baldwin's Tallac Resort and Casino was the standard of elegance and fine dining on the south shore from 1882 to 1920. A menu was handwritten each day, featuring the daily specials. Evan's Restaurant, just a few miles south of the original Tallac House, continues that fine dining tradition in 2015. Chef Evan Williams provides a daily changing menu and fine dining cuisine. Lucky would be proud. (T:LTHS) (B:EW)

Appetizers

Scallop quenelles with lobster-sherry cream	15.
Savory chile cheesecake topped with Maine lobster salad and sauteed white corn fricassee with a duet of avocado and chipotle aiolis	14.
Napoleon of veal sweetbreads in puff pastry with seasonal mushrooms and capers in brown butter with charred tomato cream and Madeira gastrique	16.
Hoisin and orange glazed prawns with Asian style slaw, served with tangerine reduction, chives and sesame seeds	14.
Millefeuille of goat cheese-hummus bread layered with spinach, tomato and sweet and salty phyllo layers, topped with truffle honey	12.
Roasted maple glazed quail stuffed with pecans, dates, apples and pancetta, served on a bed of sauteed baby spinach	14
Carpaccio of black pepper seared beef with micro arugula salad, confetti of red onions and bella olives with extra virgin olive oil and balsamic reduction	14.

We feature a fresh homemade pasta, pizza and soup of the day.
See the special board for details and prices.

Salads

Butter lettuce with julienne of apple, blue cheese and candied pecans tossed in walnut oil vinaigrette	10.
Evan's Caesar salad featuring fresh parmesan crisp, romaine lettuce and garlic crostini	10.
Warm spinach salad with duck sausage, pancetta, toasted pine nuts, shaved asiago cheese and balsamic vinegar dressing	11.
Our house salad of mixed greens, cherry tomatoes, julienne of carrot and red cabbage, cured cucumber and bay shrimp, choice of creamy basil, preserved lemon vinaigrette or house vinaigrette	9.

Entrees

Grilled filet of beef with horseradish-green peppercorn butter and syrah reduction, served with cheddar gratin potatoes and broccolini	38.
Rosemary and garlic marinated rack of lamb with raspberry wine demi-glace, parsnip mashed potatoes and minted zucchini curls	39.
Roast venison loin chop with pinot noir demi-glace, lacquered root vegetable hash, baby carrots and asparagus	40.
Panko crumb and fresh thyme breaded breast of chicken with jus de volaille, mashers, mushroom bacon sauté and green beans	27.
Porcini dusted veal loin medallions with Marsala beurre blanc, truffled wild mushroom risotto, braised Belgian endive and baby carrots	38.
Pan roasted breast and confit leg of duck with Grand Marnier jus, savory bread pudding with walnuts, cranberries, and goat cheese with snap peas	36.
Apple-porter glazed pork chop with marbled sweet potato mashers, apple chutney, assorted vegetable medley and brandy demi-glace	30.
Pan seared day boat scallops on curried apple coulis, applewood smoked bacon mashers, sugar snap peas and baby carrots	38.

Chef Dustin selects seafood and other items according to their freshness and availability to comprise our daily specials.
Dustin's vegetarian platter is available upon request, price subject to change

Desserts

Our Pastry Chef, Anthony, takes great pride in creating the most luscious and lavish desserts, designed to test your willpower.
Your server will tell you all about them, and dessert wines or cordials you might wish to enjoy as well.

Locally fresh roasted Alpen Sierra coffee and assorted teas 4. Espresso 5. Cappuccino 6.

We accept Visa, Mastercard, American Express and Discover; no personal checks
We reserve the right to refuse service to anyone.

Corkage is 20. per bottle, limit two bottles per party

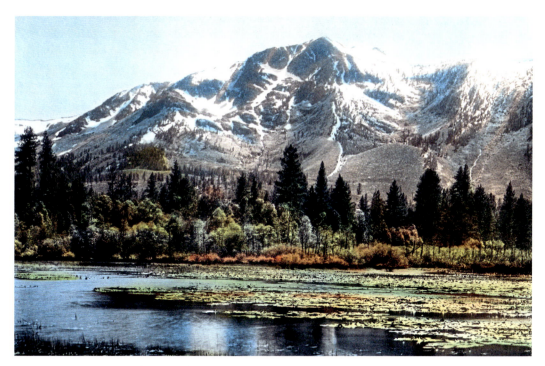

MOUNT TALLAC (MM#49), FALLEN LEAF LAKE: Mount Tallac, with its iconic "cross of snow," competes with Emerald Bay for the most photographed view at Lake Tahoe. The glacial cross is perennial and visible in spring, summer, and fall. With an altitude of 9,739', Tallac is part of Desolation Wilderness. Its name, derived from the Washoe word phonetically pronounced, "Talah-act," means "Great Mountain." It is accessible for day hikes and offers outstanding views of the Lake and Carson Valley. (T:NLTHS)

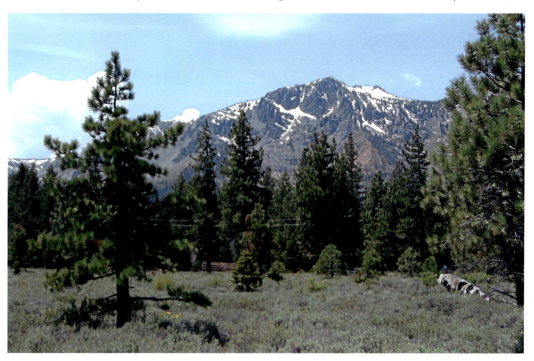

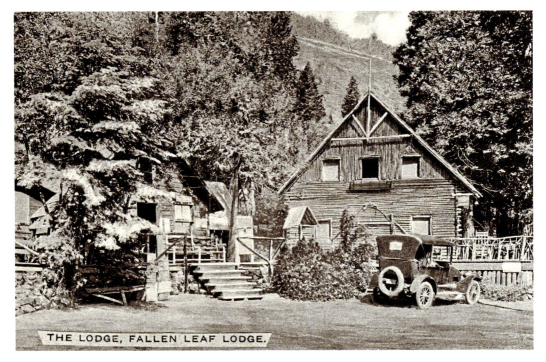

THE LODGE, FALLEN LEAF LODGE.

FALLEN LEAF LAKE STORE: Originally part of "Lucky" Baldwin's Tallac landholdings, Fallen Leaf Lake became part of Anita Baldwin's private fiefdom. Easy for her to do with a nontaxable, $2-million-a-month royalty income. Over time, squatters and private lessees established summer homes and camps. Stanford University maintains its summer camp and conference center at Fallen Leaf Lake today. The heart and focus of the area are the small store, café, and marina located on the western shore. (T:NHS)

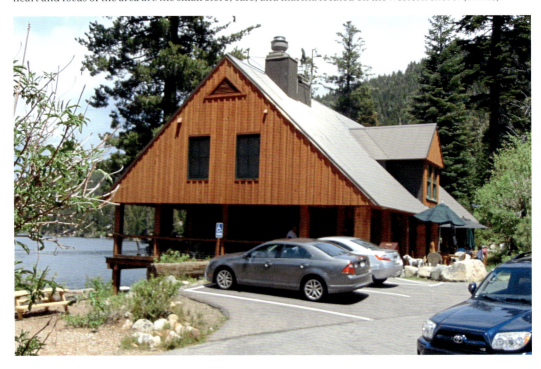

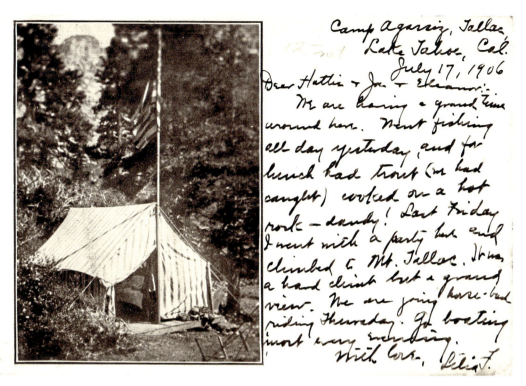

GLEN ALPINE: Glen Alpine Springs is an example of the preferred rustic and healthful living resorts so popular with late nineteenth and early twentieth century vacationers. Camp Agarriz offered fishing, swimming, horseback riding, and boating. Up the road, Glen Alpine Springs offered health-giving mineral waters for the invalid. A little farther up the trail, you could visit Modjeska Falls as you still can today.

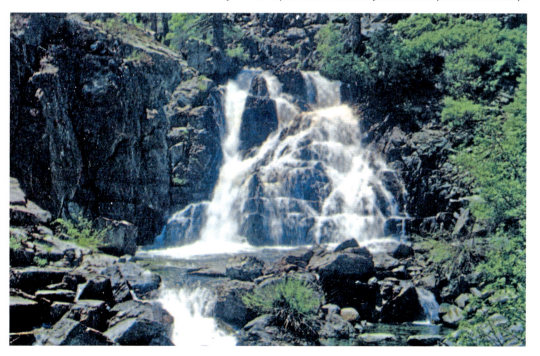

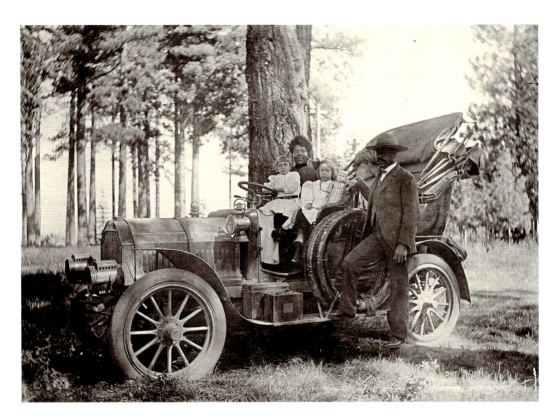

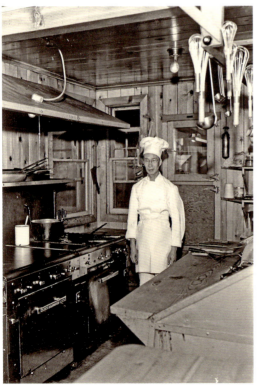

Diversity: George Cushney participated in the post-timber resource economy at Lake Tahoe as master of the kitchen and dining room at the Tallac House restaurant. Here he poses with his wife, and Gladys and Velma Comstock, in a motorcar at Tallac Resort. His daily, handwritten menus attest to the quality of the fare. The Homewood Resort was delighted to have its chef, Wing Yee, starting in 1930. After a period away from the resort, his return was the basis of a major advertising promotion to lure summer guests back to the resort. (T:LTHS)

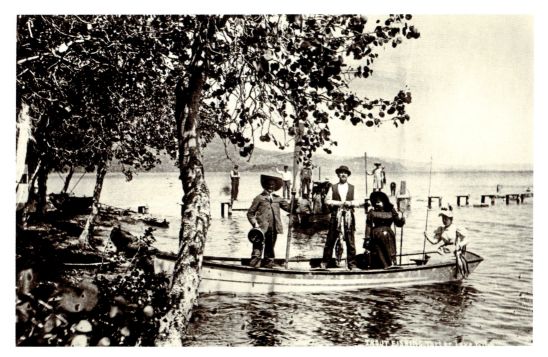

TROUT FISHING (MM#50): Preheat the grill. Clean the fish out, heads and tails on, and dress with lemon slices. Fill the body cavity with freshly cut wild onions, freshly cut parsley, salt, and pepper. Rub olive oil on the fish skin; do not remove it. Grill it for approximately eight minutes with the barbecue lid on, until the white fats start to bead on the surface of the meat. When cooked, the skin will separate from the meat of the fish. (T:NHS)

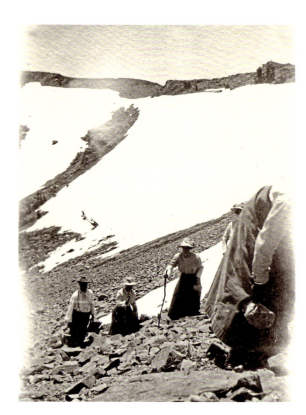

HIKING IN DESOLATION VALLEY: What would you have worn as a woman in Tahoe in 1910 to climb loose granite scree as you scale Mt. Watson? Your apparel included a dark "walking" skirt; white "pouter pigeon front" blouse; sensible high-top leather shoes; and summer straw hat. Our contemporary hiker dons shorts, backpack, t-shirt, and bandana as she hikes into the federally protected Desolation Wilderness area. Although fashion has changed over 100 years, sensible shoes are a constant. (T:KP)

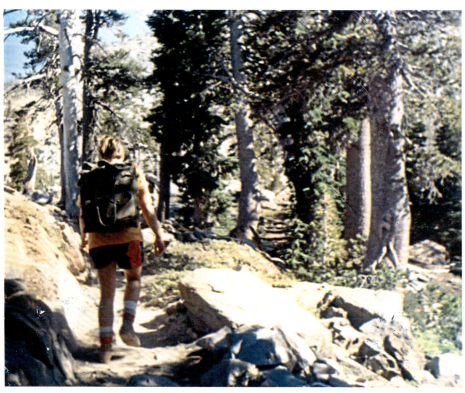

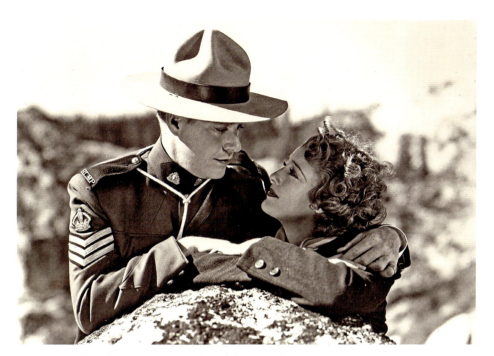

Rose Marie (1936) and *True Lies* (1994) (MM#51): Lake Tahoe has been a favorite filming location over the years. Emerald Bay substituted for the Canadian Rockies backdrop during the filming of *Indian Love Call*, released as *Rose Marie* in the United States. Nelson Eddy and Jeanette MacDonald starred along with local Washoe tribal members acting as Hollywood Sioux. Sixty years later, Arnold Schwarzenegger and Jamie Lee Curtis filmed portions of their romantic spy thriller at Lake Tahoe. Somehow, the Schwarzenegger and Curtis pairing is just not the same as Eddy and MacDonald together.

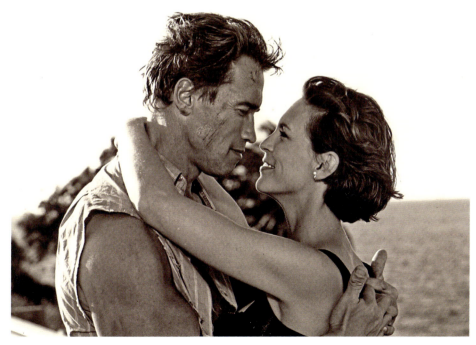

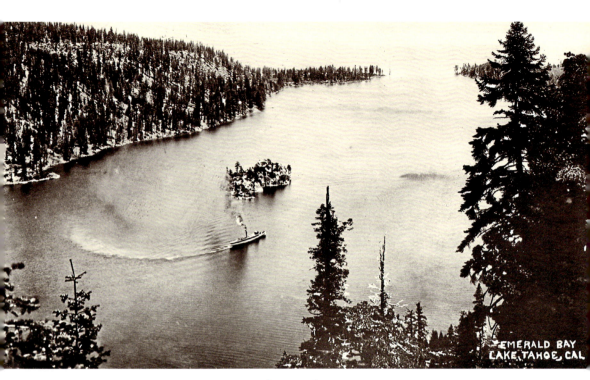

EMERALD BAY, TAHOE'S CROWN JEWEL (MM# 52): The most photographed part of Lake Tahoe is the iconic Emerald Bay. Created during the Lake's volcanic past, the bay, with tiny Fannette Island at its center, is recognized throughout the world. Its uses have included summer Washoe home, timber reserve, hermit's retreat, private summer estate, hunting lodge, and, now, California State Park.

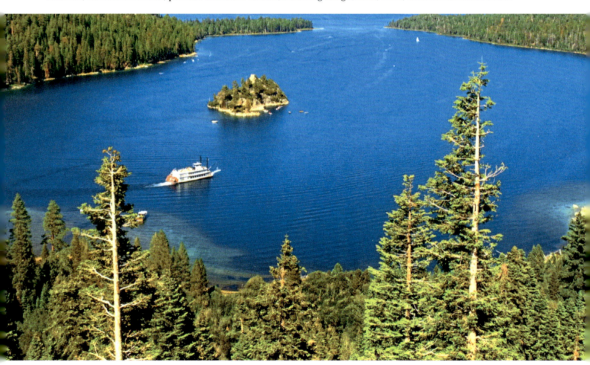

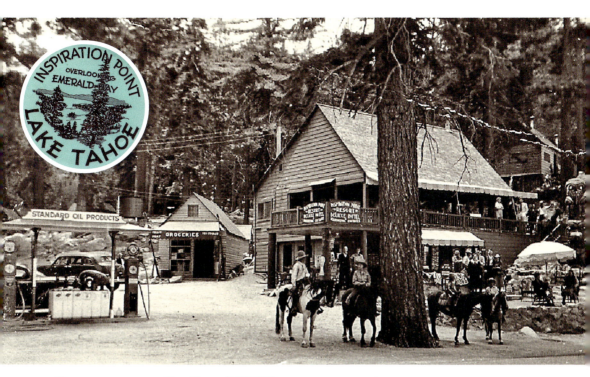

VIKINGSHOLM AND BAY VIEW (MM#53): A close runner-up for most photographed Tahoe site is the fairy-tale Vikingsholm, located at the base of Eagle Falls near the shore of the Lake. Several shoreline resorts have dotted Emerald Bay since the hermit of Fannette Island went to his watery grave. The only structure remaining today is Lora Knight's private home, originally built in 1929, and now open seasonally as part of Emerald Bay State Park.

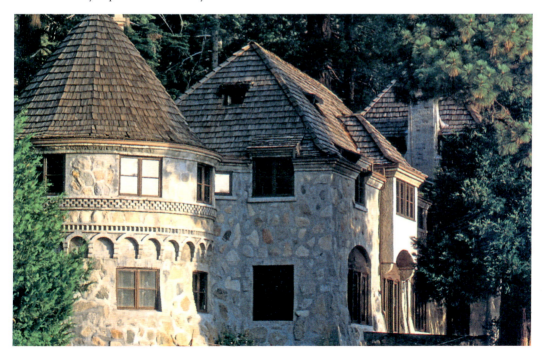

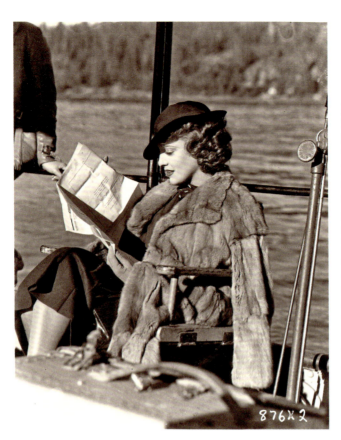

JEANETTE MACDONALD AND MEG RYAN (MM#54): Tahoe has long been home to stargazing, both celestial and Hollywood. The long daylight hours, pristine air, and scenery make it a perfect movie location. You would have seen Jeanette MacDonald cruising the Lake in a wooden boat in 1935 as she filmed *Indian Love Call* (US release: *Rose Marie* in 1936). Sixty years later, you would swerve to avoid hitting Meg Ryan as she bicycles with her eyes closed along State Highway 89 as she stars in *City of Angels* (1998).

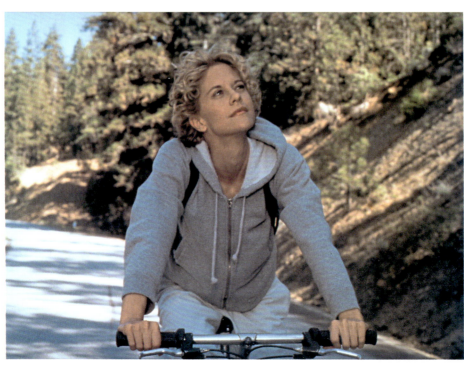

Julia Morgan and the Else Schilling House (MM#55):

Julia Morgan, known as William Randolph Hearst's favorite architect, designed three private homes in the Lake Tahoe Basin. In 1939, Ms. Morgan was commissioned to design the "Bow Bay" house for Else Schilling, who was heir to the A. Schilling spice and coffee line of San Francisco. The 4,000-square-foot, nine-bedroom mountain cottage overlooking Rubicon Bay was designed with Ms. Schilling's Bavarian family ancestry in mind. (T:SLO) (B:SLO)

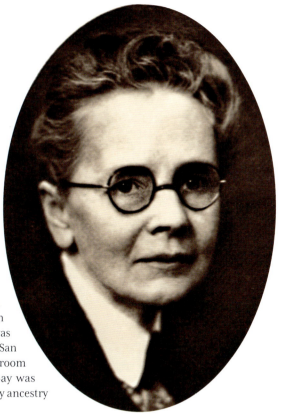

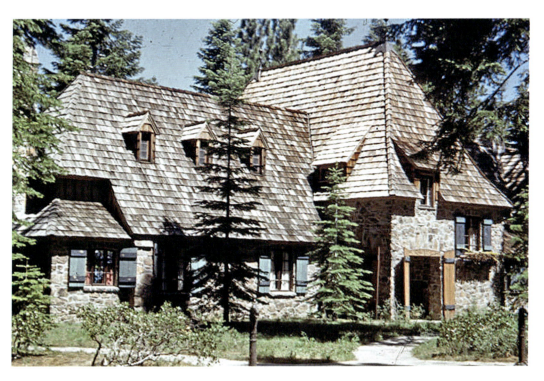

PINE LODGE AND THE HELLMAN/ERHMAN PROPERTY, TAHOMA, CALIFORNIA (MM# 62): Isaias W. Hellman, investment banker, was one of the first wealthy Californians to recognize the value of Lake Tahoe as a private summer home retreat. In 1897, Hellman acquired Sugar Pine Point from D. L. Bliss and commissioned fledgling architect Walter Bliss to design the Hellman summer retreat. The family enjoyed the private property, aptly named "Pine Lodge," until 1965. You can enjoy it today as part of Ed Z'berg Sugar Pine Point State Park. (T:FD)

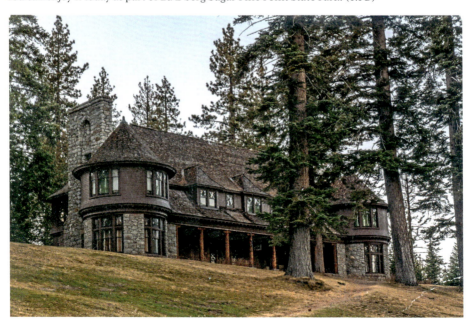

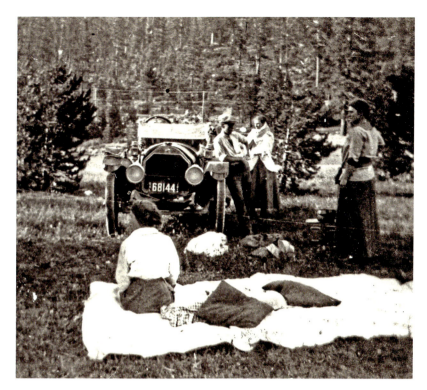

AL FRESCO DINING AND CLASSIC CARS (MM#63): Whether you are driving a 1909 Oldsmobile touring sedan or a 1957 Chevrolet convertible, packing a picnic basket is an excellent idea. The adventure of traveling the West Shore was an early touring draw once the road around Emerald Bay was established. In 2015 the Great Gatsby Festival at Valhalla and Hot August Nights in Reno draw classic cars for a drive around the Lake. (T:LTHS)

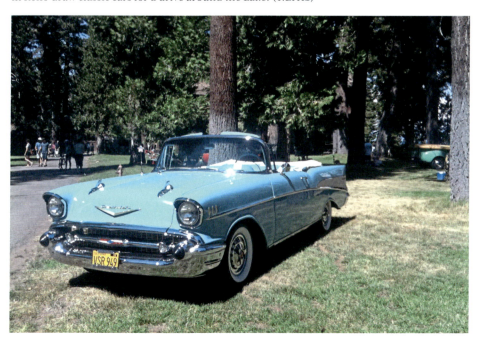

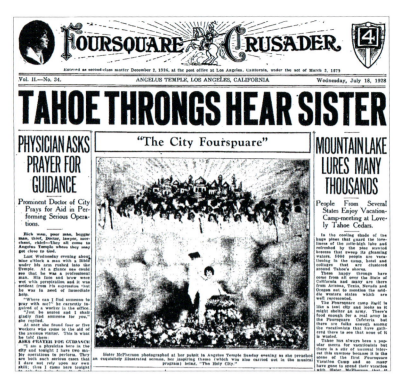

AIMEE SEMPLE MCPHERSON AND TAHOE CEDARS, CALIFORNIA: Tucked next to the Norfolk Woods Inn in Tahoma is a diminutive cabin. Evangelist minister Aimee Semple McPherson reportedly stayed there as Tahoe Cedars began its brief life as a summer religious retreat for the Four-Square Church in 1927. It is one of the few remaining log cabins on the West Shore. In 2015 visitors can rent the period-decorated cabin. (T:4SQ) (B:4SQ)

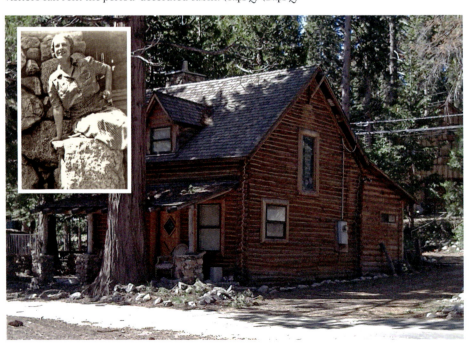

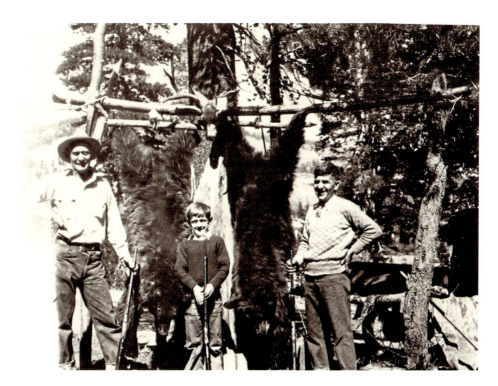

CALIFORNIA BROWN BEARS:
The California Brown Bear (*Ursus arctos*) is found throughout the Sierra Nevada and has made the Lake Tahoe Basin its home. Originally hunted as a threat to stock and then for sport, bears are now a common sight in the increasingly suburban Tahoe area. The Bear League of Homewood reminds us all to be "bear aware" and to keep food safely hidden. (B:NLTHS)

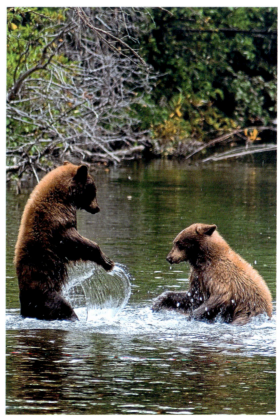

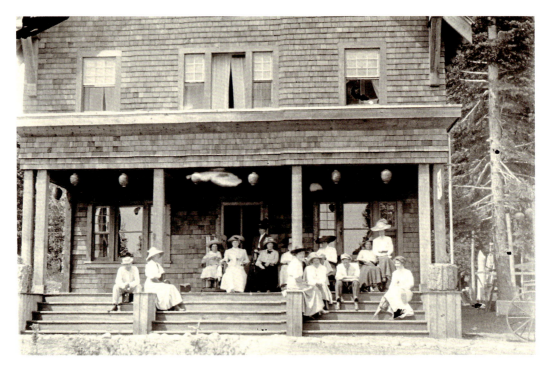

HOMEWOOD ON THE MAGICAL WEST SHORE, CALIFORNIA (MM#66): Homewood Resort, established in 1910, was an early popular, reasonably priced vacation destination offering weekly holidays on the American plan (three meals a day). Visitors would train to Truckee, coach or train to Tahoe City, and steam via the *SS Tahoe* to the Homewood pier. Innumerable Bay Area and Central Valley schoolmarms and spinsters arrived together for a week at the Lake. (T:KP)

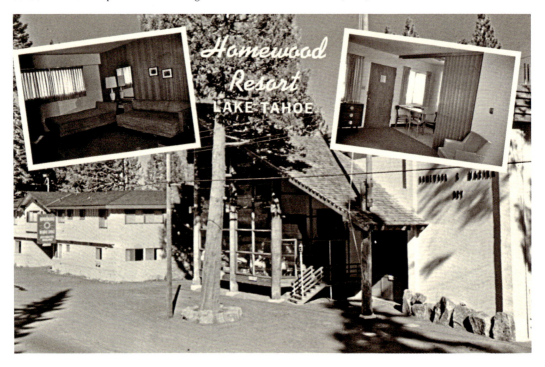

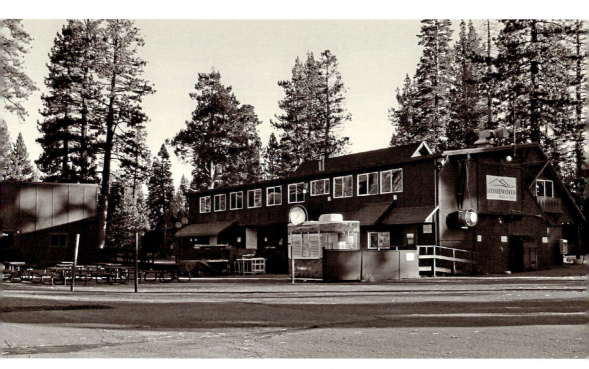

HOMEWOOD SKI RESORT, CALIFORNIA (MM# 66): Homewood Ski Resort and Ski Bowl Resort combined in 1987 to create the only ski run on the West Shore, the Homewood Mountain Resort. Today it is an expanding mixed-use residential and commercial area with visions of building a multi-story "Squaw Valley-like" retail and residential destination resort. (B: TIL)

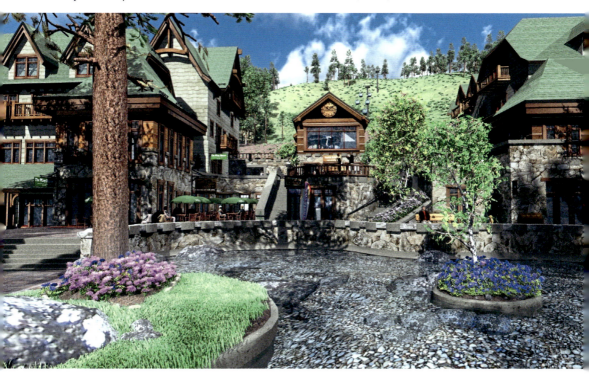

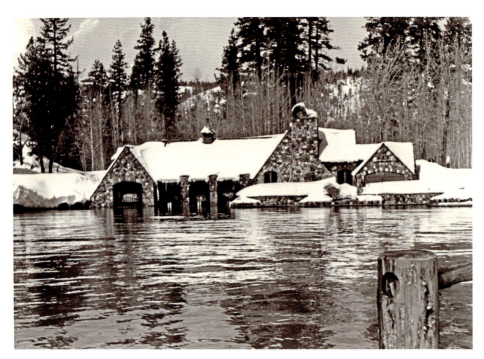

KAISER ESTATE AND FLEUR DU LAC, TAHOE PINES, CALIFORNIA (MM#67): Tahoe has a history of hosting private compounds and residences. The Henry J. Kaiser estate, built for the construction materials and shipyard magnate, is a good example of a large private estate developed into a gated community of many small, private houses. Property taxes, estate taxes, multiple heirs, and changing tastes have led to fewer large estates in Tahoe in recent years, although the desire for a private retreat continues. Welcome to Fleur du Lac at Tahoe Pines. (T: NLTHS)

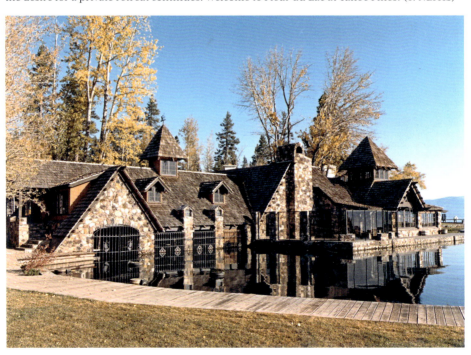

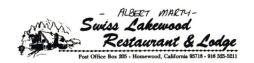

GRAND MARNIER SOUFFLES

SERVES 6 PERSONS

- 6 teaspoon (¼ stick) butter, softened
 Sugar
- 6 eggs separated
- ½ cup sugar
- ¼ cup fresh orange juice
- 3 tablespoon Grand Marnier
- 2 tablespoons finely grated orange peel
- 1 tablespoon fresh lemon juice
 Powdered sugar

ALPINE DINING AND SWISS LAKEWOOD:
The European Alpine theme runs heavily through Lake Tahoe culture. Alpine metaphors and similes abound, never more so than in our architecture and food. Swiss Lakewood restaurant offers both. A forty-plus-year fixture on the West Shore, it is the Rubicon property owners' dining experience of choice. For the traditionalist, Swiss Lakewood offers continental cuisine and still does it well after all these years.

Preheat oven to 450°F. Butter 6 individual souffle dishes 4 inches in diameter, using 1 teaspoon for each. Dust each dish with sugar, shaking out excess.

Combine egg yolks, 7 tablespoon sugar, orange juice, liqueur and peel and whisk just until blended. Beat egg whites with 1 tablespoon granulated sugar intil soft peaks form. Add lemon juice and blend thoroughly. Fold yolk mixture into whites. Spoon into souffle dishes. Use thumb to make rim around outer edge of souffles. Bake until puffed and browned, about 10 minutes. Remove dishes from oven. Sprinkle tops with powdered sugar, set dishes on napkin-lined plates and serve immediatley. (with Grand Marnier Sauce)

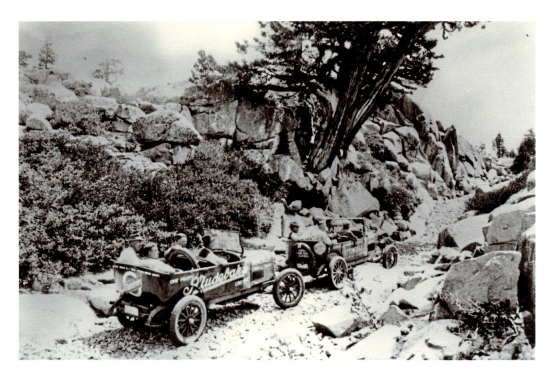

RIDING THE RUBICON: The route to Lake Tahoe from Placerville originally took drivers from Georgetown across the edge of Desolation Valley and past the Rubicon Resort. Horses or mules were best, but this new Studebaker proved the route passable by a horseless carriage in 1926. You can relive that experience today by "Riding the Rubicon" with the Jeeper's Jamboree. Take your chains, winch, and jack, but leave the Tesla at home. (T:ED)

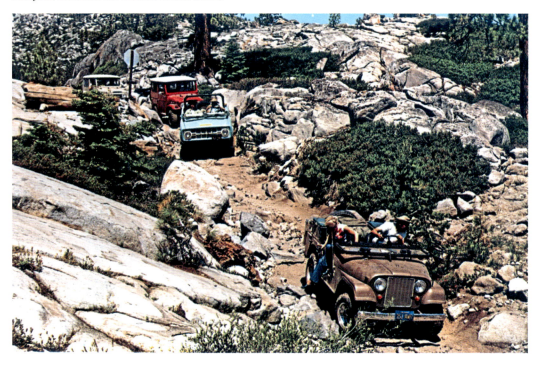

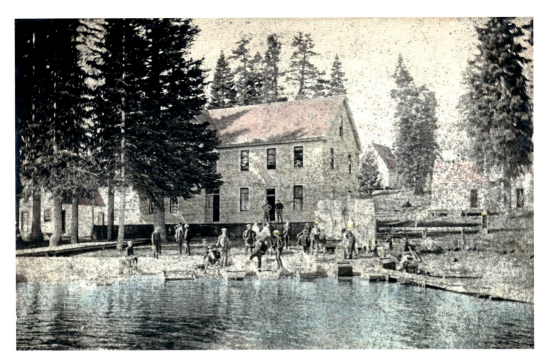

McKinney's and Chambers Landing, California: Chambers Landing and its previous incarnation, McKinney's, claim to be the oldest sports lodge on the lake, dating back to 1863. The pier and bar were built shortly thereafter and began welcoming guests in 1875. One hundred years later, the infamous "Tahoe Punch" was born. It is a combination of light and dark rums; orange and pineapple juices; sweet and sour and grenadine for color; and a floater of 151-proof rum. The actual proportions are a secret.

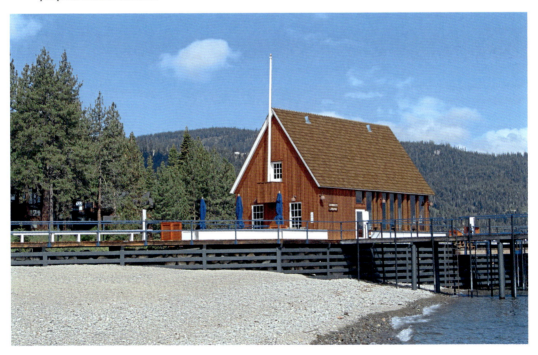

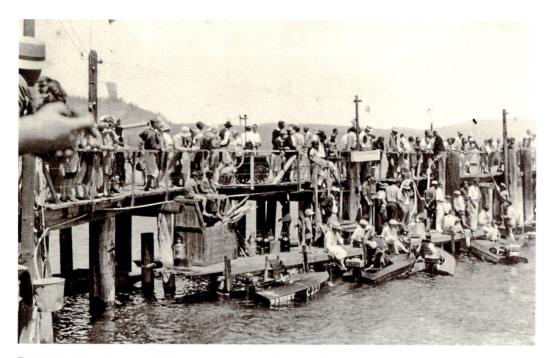

BOATING: The outboard and inboard motor engines have each been king for recreational boating at Lake Tahoe ever since the internal combustion motor was invented. Sail and steam were fine for fishing and timbering. However, for a good (fast) time, bring your 1930s "woody" or contemporary fiberglass speedboat. Powerboat racing has been a mainstay of summer fun since Henry Kaiser challenged Stanley Dollar for the Tahoe Yacht Club crown. (T:PLACER)

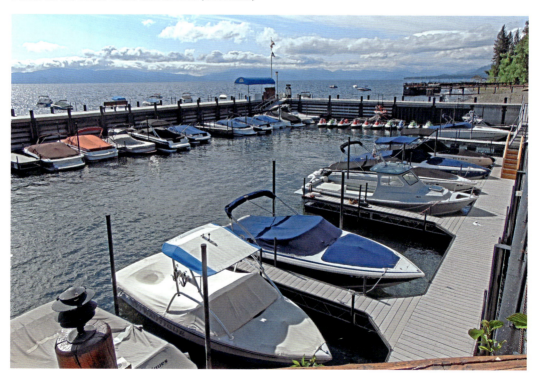

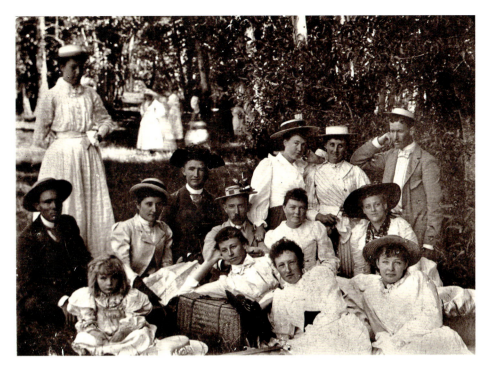

PICNICKING AT 6,224' (1,897 M) ELEVATION: Family, friends, and fraternal organization day outings and picnics are a favorite part of nineteenth century recreation. Dressing well, even for a picnic, was a tony preference for the higher-end guests that the better resorts wished to attract. These mutton-leg shoulder and upper arm women's blouse treatments date this image to the 1880s. Our contemporary picnic crowd is more informal but has just as much fun dining in the forest. (T:NHS)

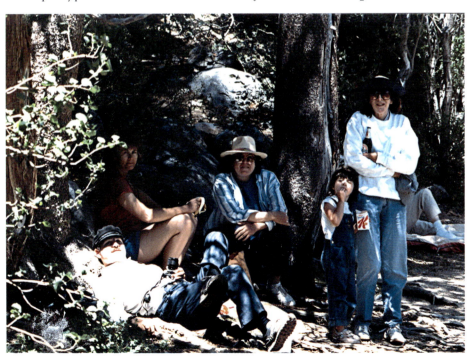

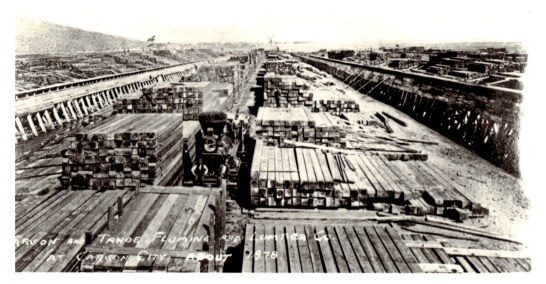

LUMBER INDUSTRY: From the 50,000 acres of Tahoe Basin timberland, the D. L. Bliss operation removed 750,000,000 board feet of lumber and 500,000 cords of wood in its twenty-five years of business that ended in 1898. Today, you can count the individual trees removed and visitors to the area are shocked to see that timber was removed from the forest. This stack of trees was removed from the Tahoe National Forest as part of a fire control effort.

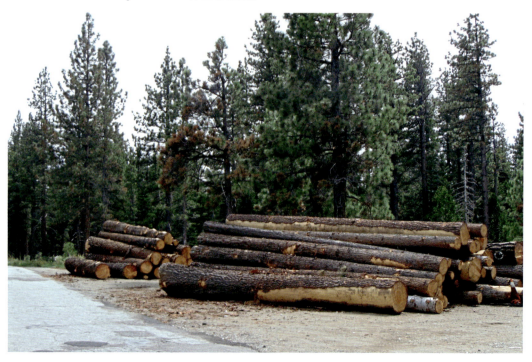

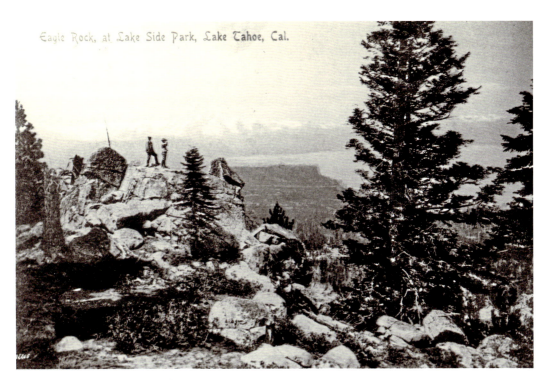

Eagle Rock, at Lake Side Park, Lake Tahoe, Cal.

EAGLE ROCK (MM #68), IDLEWILD, CALIFORNIA: Overlooking Highway 89 and the lakeshore is a vestige of Lake Tahoe's geologic past. Eagle Rock, referred to in the local newspaper, the *Tahoe Tattler*, in 1881 as Eagle Cliff, is a volcanic outcropping rising 62' above the Lake. An easy half-mile hike takes you to the top, as it has taken Washoe and European visitors for centuries.

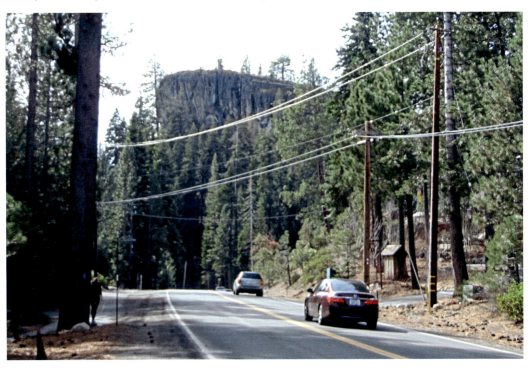

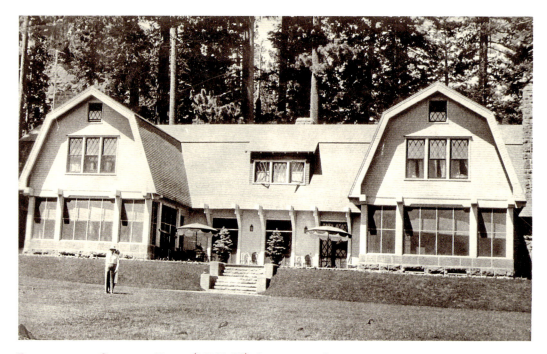

FLEISHHAKER SUMMER HOME (MM# 69), IDLEWILD, CALIFORNIA: Herbert Fleishhaker, philanthropist and president of the Anglo California National Bank, built his home near Blackwood Canyon in Idylwild, as the Edwin B. Crocker family named the area. The "double" Dutch colonial-style home was remodeled in the twenty-first century. The reason for creating a "single" Dutch colonial evades the author. Win undying gratitude by emailing the author at: cajensen@pacbell.com with the answer.

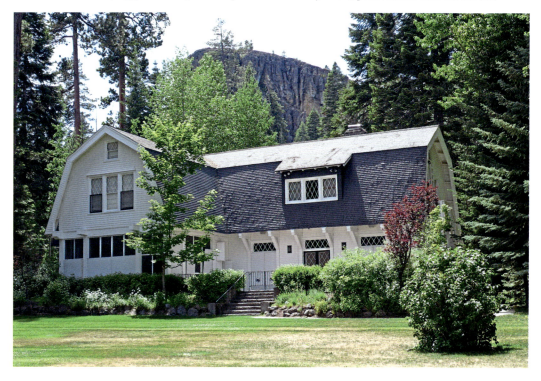

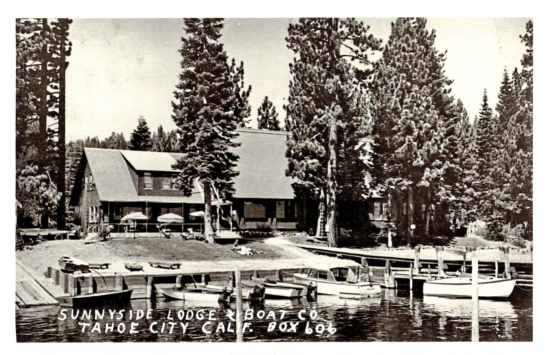

SUNNYSIDE RESORT, CALIFORNIA (MM#70): Built as a residence in 1908, Sunnyside Resort became a modest commercial lodge and marina in 1946. It evolved to its current manifestation as Sunnyside Restaurant and Lodge in 1987. It is part of a family-owned, waterfront themed group of restaurants located in California and Hawaii. (T:KP)

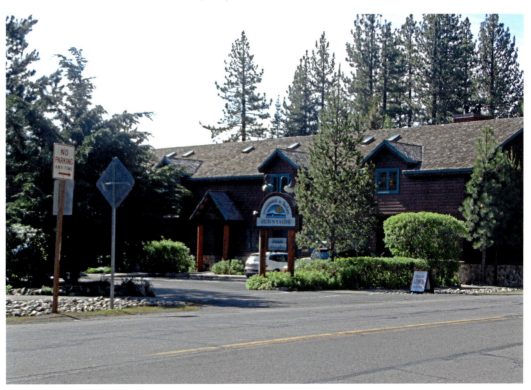

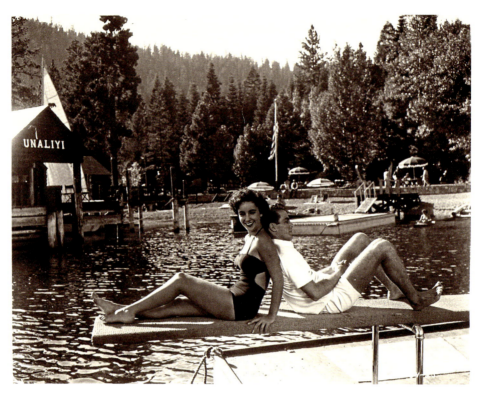

DOLBY RESIDENCE: It is surprising how many people are connected by Lake Tahoe real estate. The Dolby residence was the filming location for *A Place in the Sun* (1951) with Elizabeth Taylor and Montgomery Cliff, a controversial movie of its day. In 1979, audio pioneer Ray Dolby and his wife, Dagmar, purchased this summer home constructed in 1929 as a family retreat. Their son, David, returned years later to his parents' summer home to film *Last Weekend* in 2014.

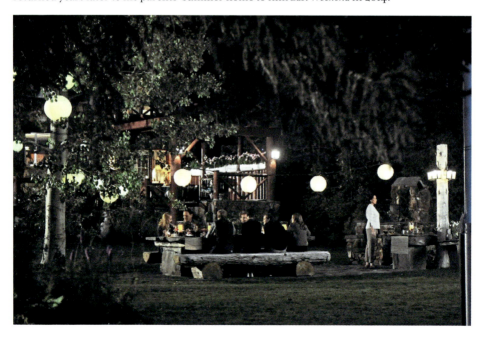

GRANLIBAKKEN, TAHOE CITY, CALIFORNIA: Contemporary Granlibakken became part of Tahoe Tavern in 1928 and soon gained renown as "Olympic Hill," the site of the 1931 Olympic Trials, local ski club competitions, sleighing, snow sculptures, and wonderful winter fun. The site's ownership and use have changed over the years as the property has been home to the University of California at Berkeley's "Lair of the Bear" summer camp. Today we enjoy it for year-round resort living, conferences, skiing, and forest adventure courses.

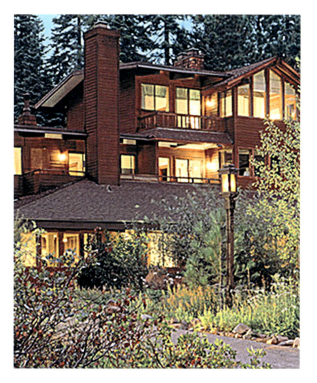

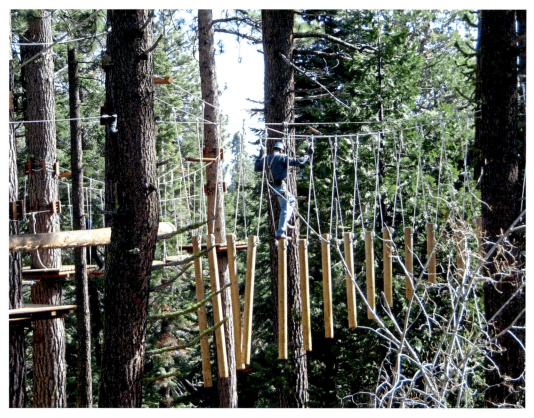

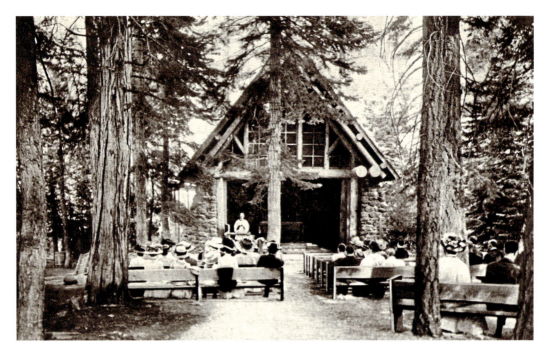

CHAPEL OF THE TRANSFIGURATION, TAHOE CITY, CALIFORNIA (MM#71): Also known as the Chapel of the Pines, this outdoor chapel was the first church in Tahoe City and was constructed on the Tahoe Tavern grounds. It has held summer religious services continuously since its construction in 1909. Today, the chapel is incorporated as part of the St. Nicholas Episcopal Church. Services are held on Sundays and the facility is available for weddings during the summer months. (T:KP)

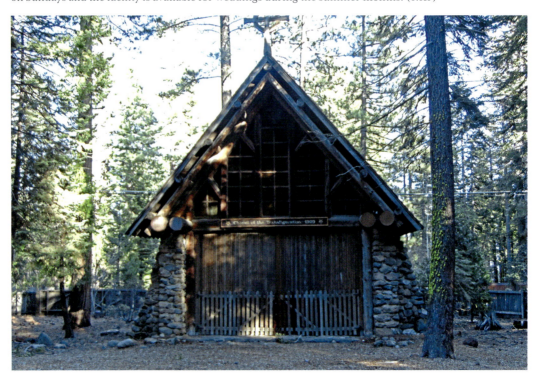

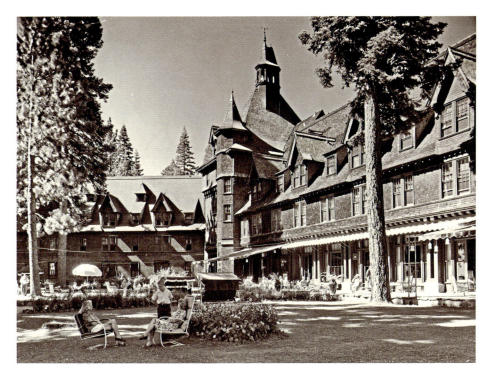

Tahoe Tavern, Tahoe City, California (MM#71-72): D. L. Bliss did not invent the hospitality industry at Lake Tahoe, but he redefined it. The opening of the Tahoe Tavern in 1902 virtually changed the region's main industry overnight – from timber and mining to hospitality and tourism. The Bliss organization marketed the resort extensively, focusing on a wealthy clientele. Regrettably, the resort closed in 1964, was scheduled for demolition, and was then swept by a devastating fire. The present Tahoe Tavern properties are private residential condominiums built by the Moana Development Corporation between 1966 and 1969.

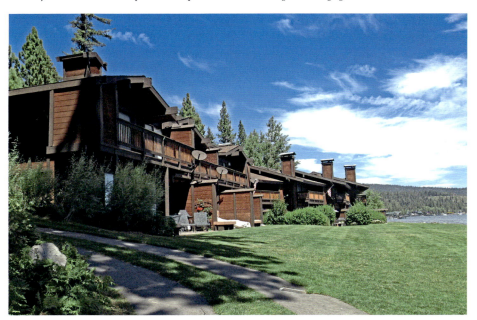

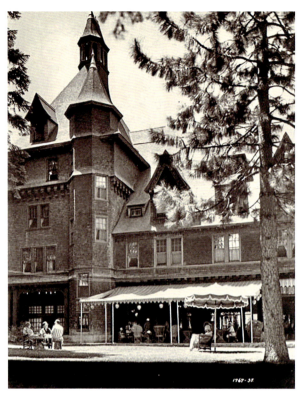

Tahoe Tavern, Tahoe City, California (MM#71-72): This beautiful hotel designed by architect Walter Danforth Bliss, son of D. L. Bliss, boasted rooms for 450 guests, steam heat, telephone/telegraph service, electricity, private baths, and every modern amenity. The $500,000 loan secured to create the forty-acre resort property was worth the investment. Tahoe Tavern was an instant five-star success! In 2015 you can own a condominium at the new Tahoe Tavern Properties, offered from $729,000 to $2,200,000.

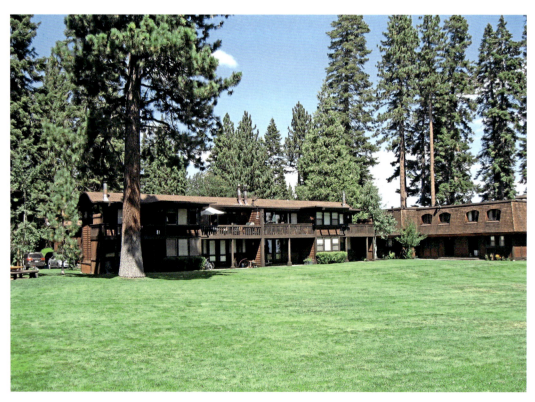

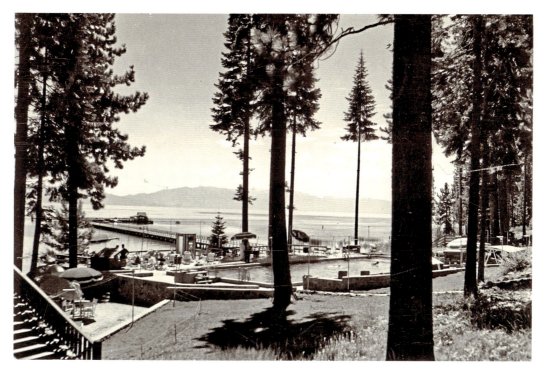

TAHOE TAVERN SWIMMING POOL (MM#71-72): The remaining elements from the original Tahoe Tavern that have been incorporated into the condominium properties are the swimming pool, stair access to the beach, and a short pleasure pier. The same recognizable trees ring the pool today, only a little taller and wider. (T:DD)

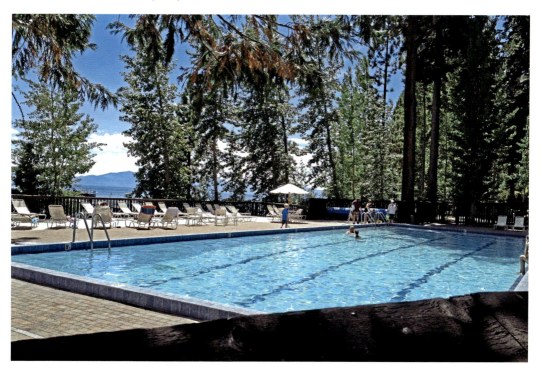

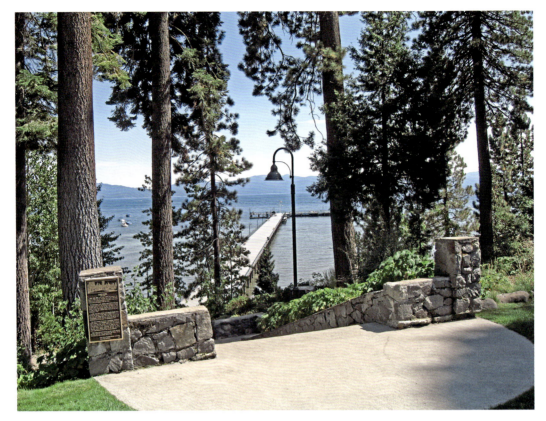

Tahoe Tavern Pier and Access (MM#71-72): Wander down the original steps from the Tahoe Tavern to the beach and pier. Here you can seek the time portal. Once back in the twentieth century, you may cruise the lake on the *SS Tahoe*, catch Lahontan cutthroat (Lake) trout, chat with George Wharton James, pose for photographer Harold Parker, and ride the narrow-gauge *Glenbrook* locomotive. (B:LOC)

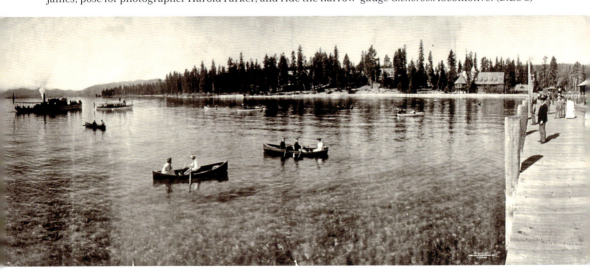

Harold and Marjorie Parker and the League to Save Lake Tahoe:

Seasonal Tahoe Tavern Studio photographer Harold A. Parker (1878-1930), assisted by his wife, Marjorie Parker, took many of the iconic images we associate with Lake Tahoe. Parker wooed and won his wife while he was the Tavern photographer from 1906 to 1913. View his panoramic and hand-colored Tahoe images at the Gatekeeper's Museum in Tahoe City. Ensure Lake Tahoe continues as the Gem of the Sierra that Parker captured in his glass-plate negatives and photographs by embracing the League's motto: "Keep Tahoe Blue." (T:DP)

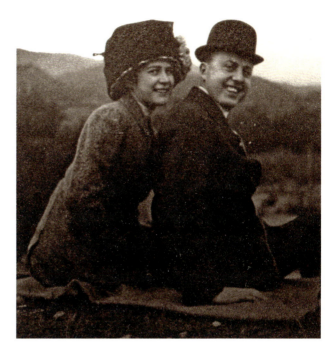

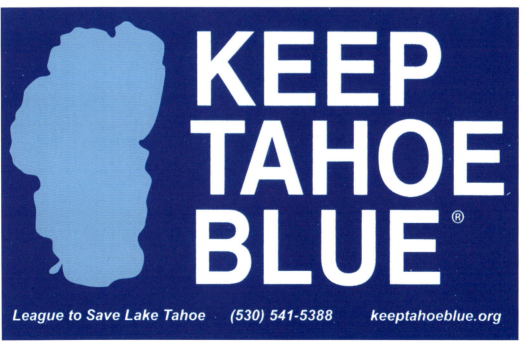

Acknowledgments

A debt of thanks to the following individuals and organizations: Rebecca Phipps, Executive Director, North Lake Tahoe Historical Society; University of Nevada, Library, Special Collections; Diane Johnson, Executive Director, Lake Tahoe Historical Society; Mary Morganti, Director of Library & Archives, California Historical Society; University of California, Bancroft Library; San Francisco Public Library History Room; Huntington Library, San Marino; Lee Brumbaugh, Photo Curator, Nevada Historical Society; Debbie Poulson, Placer County Archive; Darrel Cruz, Washoe Tribe of Nevada and California; John Walker, Nevada State Railroad Museum; Frances Dinkelspiel, personal Ehrman family collection; Art Sommers, personal collection; Chuck Day, Max Day Real Estate, personal collection; and Evan Williams, Evan's Grill, South Lake Tahoe. Thank you to Heather Marino, Fonthill Media acquisitions editor, for her ongoing interest in California history. Omissions of your favorite locales and content errors are all mine.

Donald Parker, Jr., grandson of Harold and Marjorie Parker, has been most generous with his encouragement to delve into the visual legacy of the Tahoe Tavern Studio. My gratitude is extended particularly to postcard club (http://www.postcard.org) members Ken Prag of San Francisco and Dorothy De Mare of Petaluma for the kind use of their personal collections. The aid and patience of the irreplaceable Robert D. Haines, Jr., cannot be overstated. Thank you to Rick Brower of South Lake Tahoe who is filled with information about the Anita Baldwin family. The Tahoe Geocachers – Reno Raiders and "AppleJohn" – assisted with mile-marker locations. Finally, writing is impossible without the excellent and thorough copy editor extraordinaire, Marcy Protteau. Thank you!

Please email the North Lake Tahoe Historical Society at info@northtahoemuseums.org if you can contribute to Lake Tahoe history with oral histories, family documents, letters, photographs, or ephemera. The Tahoe lifestyle, good times, wildlife, recreational opportunities, and water deserve our protection. Do your part to save this wonderful resource.

Photo Credits

All images are from my personal collection except where indicated. Photographic credit(s) are identified at the end of the caption by "top" (T) or "bottom" (B) of the page. The following organizations and collections kindly allowed the use of their images: Bancroft Library, University of California, Berkeley (BANC); California Historical Society (CHS); California State Railroad Museum (CRM); Dorothy De Mare, private collection (DD); El Dorado County Museum (ED); Foursquare Church, Heritage Center Archive (4SQ); Frances Dinkelspiel, private collection (FD); Evan Williams (EW); Google Earth (Google); Lake Tahoe Historical Society (LTHS); McAvoy Layne (ML); Nevada Historical Society (NHS); Nevada State Railroad Museum (NRM); North Lake Tahoe Historical Society (NLTHS); Donald Parker, Jr. (DP); Harvey and Lois Perman, private collection (HP); Placer County Archives (PL); Ken Prag, private collection (KP); Marcy Protteau, private collection (MAP); San Francisco Public Library, History Room (SFPL); Special Collections and University Archive, Robert E. Kennedy Library, California Polytechnic State University, San Luis Obispo (SLO); Michael Silver, private collection (MS); Art Sommers, private collection (AS); David A. Tirman, AIA, private collection (TIR); United States Library of Congress, Washington, DC (LOC); University of Nevada, Library, Special Collections (UN); and Washoe Tribe of Nevada and California (WASHOE).